THE COMPLETE POTTER:
SLIPS AND SLIPWARE

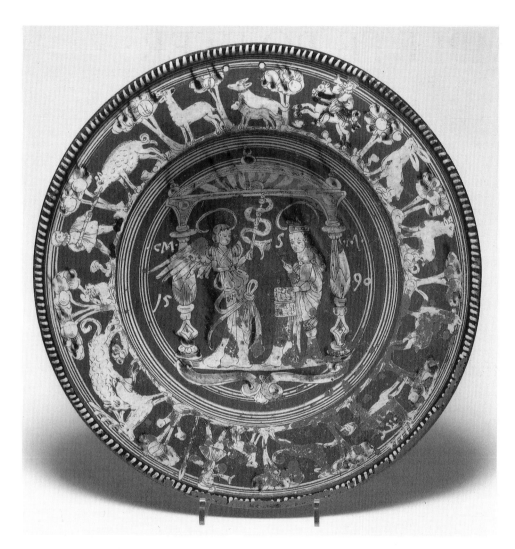

Large dish, *Wanfried-an-der-Werra, Germany, 1590.*
This large dish with its sophisticated sgraffito and trailed decoration was made in a red earthenware clay. The decoration is white slip and splashes of copper over the surface add a mottled green to the red and white of the clays. (Fitzwilliam Museum, Cambridge).

THE COMPLETE POTTER:
SLIPS AND SLIPWARE

ANTHONY PHILLIPS

SERIES EDITOR EMMANUEL COOPER

B.T. Batsford Ltd, London

First published in paperback 1994

Reprinted 1996

ISBN 0 7134 7713 X
Typeset by Servis Filmsetting Ltd
and printed in Hong Kong

for the publishers
B.T. Batsford Ltd
4 Fitzhardinge Street
London W1H 0AH

CONTENTS

INTRODUCTION

Slip decoration is as old as pottery itself. Archaeological evidence shows that it did not take long for the earliest potters to learn to use different coloured clays to decorate their pots. Initially they would have used clays which were dug out from different seams in the ground; later they added vegetable and animal matter and various minerals to alter the colours. Slip remained the principal decorative medium for thousands of years wherever pottery was made: the potters of pre-Columbian America became immensely skilled in making and using coloured slips with burnished sufaces by the beginning of the first millenium AD; the Greeks mastered the art of oxidized and reduced slips to alter their colours between 750 and 300BC; Tzu-Chou pottery, made in China from the tenth century AD, was a beautiful expression of slip painting and sgraffito on stoneware, whilst the high point of European slip decoration was in the fifteenth and sixteenth centuries AD. By the middle of the twentieth century, however, it had more or less died out, except in isolated potteries that retained their old methods as everyone else moved on. It was

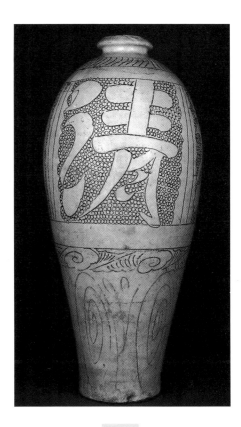

industrialization and mass-production that put an end to slip decoration.

In Britain the techniques of slip decoration were almost entirely abandoned by the end of the nineteenth century, and there has been very little continuity of tradition. Potters have had to rediscover the methods, and it has not always been easy. The rise of the artist-potter, particularly since the Second World War, revived interest in all the pre-Industrial Revolution techniques like slip decoration and salt-glazing, and has brought in new techniques from abroad like raku and reduced stoneware – methods which by their very nature must be done by hand rather than by machine.

Vase decorated with a sgraffito design of Chinese characters. *Cizhou (Tz'u Chou) ware, North China probably Hebei or Hunan. 37.5 cms high. 11th–12th c. AD. The sgraffito decoration is incised through a white slip to reveal a black slip layer underneath on the upper part of the vase, lower down the sgraffito goes through to the grey clay body. (British Museum).*

Of all the old methods the use of slip has, until recently, received little attention – surprisingly since it is such a simple material and can be used in so many ways to such varied effect. Perhaps the reason is that the twentieth-century pottery revival was based on the stoneware tradition, and slipware is part of the earthenware tradition. Even though there are now many potters using slip, few are using it on stoneware pottery.

One advantage of the break in tradition is that potters do not feel so restricted by convention and have been able to adapt methods to their ideas rather than their ideas to the method. The easy availability of materials and also the advent of new colours and materials have also helped.

It is impossible to write a truly comprehensive book on slip decoration, for one of the joys of ceramics is that it is always possible to find new ways of using old ideas. My aim has been to describe the main methods of slip decoration together with some pointers to new directions to encourage you to explore and devise your own processes.

I have also tried to give as much information as possible about the other aspects of pottery-making from clay to firing, in order to give an over-view to the whole process and enable you to get started. It also helps to show, I hope, that slip decoration is not a highly specialized technique requiring unusual materials or processes.

Inevitably there is insufficient room to

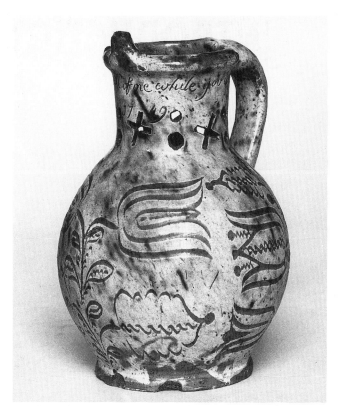

Puzzle jug, *Donyatt, Devon, England, 1749. Made in red earthenware clay and covered in a white slip, the bold decoration using a broad tool is free and yet clearly done by someone skilled in the art. It is typical of many made at the time. It is inscribed 'Fill me full Drink of me while ye wool'. (Fitzwilliam Museum, Cambridge).*

describe some areas of knowledge fully, and so the bibliography has been included to guide you to other books specializing in other areas of the art of pottery.

1 HISTORY OF SLIP DECORATION

Slips were used to decorate unglazed pottery from the earliest times, and today we find, not only from Mesopotamia (Iraq) and Egypt but also from Iran, Cyprus, Israel, Jordan, and Turkey, many examples of these ancient wares which were made for functional, decorative, and ceremonial needs. Consignments of pottery from China which first reached the Middle East from the eighth century AD gave the spur to better-quality glazed wares using both lead and alkaline glazes.

ISLAMIC

Islamic pottery is a continuation of the ceramic tradition of Mesopotamia and Egypt, a tradition which can claim the earliest-known pottery and goes back 7000 or 8000 years. One of the principal characteristics of Middle Eastern ceramics is the use of alkaline glazes often coloured with copper, which give the rich vibrant turquoises that are so striking.

In Eastern Iran, Afghanistan, Samarkand, and Nishapur lovely slip-painted dishes were

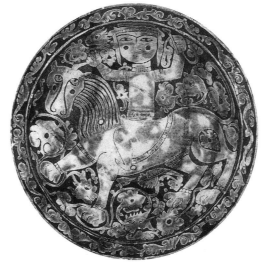

Shallow dish, *14 in. (35.5 cm) diameter, North Iran, 900–1300 AD*
A richly decorated sgraffito dish showing a figure mounted on a rampant lion. The sgraffito decoration has been carved through a white slip layer revealing the red clay body underneath. Copper oxide has been painted on to create random blotches of green in the glaze. (British Museum, London).

made from the ninth to the eleventh centuries; the decoration was often in black or reddish-brown on a white slip ground and covered in a colourless lead glaze. Some had simple Cufic inscriptions, others were much more elaborate.

In Northern Iran, in the regions of Mazenderan and Garrus, a separate style of sgraffito ware developed in the tenth century and lasted until the thirteenth century. Designs were incised through white slip to a dark red body underneath and covered in a clear glaze. Birds, animals, and human figures were favourite subjects and the background was often very elaborate.

During the occupation of Iran and much of Central Asia by the Seljuq Turks fresh attempts to imitate the Chinese porcelains were made by the use of alkaline glazes and a white body containing a large proportion of fritted glass. One very striking technique involved coating the white body in a thick black slip and then carving through, leaving a design in black on white. A turquoise or clear glaze was used. These date from the second half of the twelfth century. Thereafter

the attention of Islamic potters turned to underglaze painting with oxides.

PRE-COLUMBIAN

No discussion of slip decoration can fairly exclude the beautiful pottery of the pre-Columbian era in the Americas. The unglazed and burnished ceramics painted in natural clay colours and made with such imaginative forms are a source of inspiration to any potter interested in using slips.

The first appearance of ceramics was in Central America at the beginning of the second millenium BC. From that time until the Spanish Conquest in the sixteenth century AD pottery flourished in all the many civilizations in the continent, with a great variety of styles in form and decoration. Methods of manufacture were pinching, coiling, and the use of moulds. Throwing was never used. Glazing was almost unknown, though some use was made of vitrified slips ('plumbate ware').

Pre-Columbian potters were experts and knew how to modify their clays with materials like mica, quartz, and crushed pottery to give them the right characteristics to work with and for firing. The pots were mostly covered with slip and then painted with slips, often coloured with animal or vegetable matter. They were then burnished and fired in an open fire or an earth oven (an underground oven spread with a layer of dried dung on which the pots were placed).

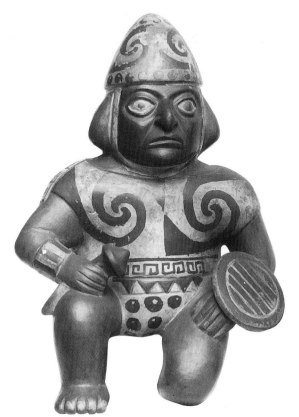

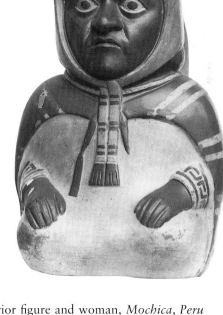

Kilns were sometimes used but only for special pots.

The pottery styles were diverse. Mochica pottery from Peru is well known for beautifully-modelled forms like stirrup vases and vividly descriptive paintings of daily life. On the south coast of Peru, Nazca pottery

Warrior figure and woman, *Mochica, Peru*
Two fine examples of Pre-Columbian pottery, probably made in the first millenium AD, though dating is difficult. They have been painted in several colours of slip and then burnished and fired unglazed. (Museum of Mankind, London).

became very sophisticated with up to eight colours of slip used in stylized designs of mythical animals and plants. The stirrup-shaped vessel was common throughout Middle and South America as was the attraction to anthropomorphic forms. Cups in the shape of a human head, animal, and bird forms are a common development and are achieved with a feeling for three-dimensional form that is breathtaking.

The Mayans in Central America made a wide variety of excellent monochrome pottery followed later by polychrome ware painted with narrative scenes depicting ceremonial and daily life in a way that is reminiscent of Egyptian painting though in a very different style. At Teotihuacan in Mexico tripod vessels were made that were painted, inlaid, and had applied relief decoration.

Further north, in the south-western United States, some very fine burnished ware was made – Mimbres pottery being one of the most notable. Made in the period AD 1000 to 1200, it is characterized by designs painted mainly in black on white with human, animal, and insect forms as a basis for stylized geometric patterns which display a real skill in design and influenced pottery-making over a wide area.

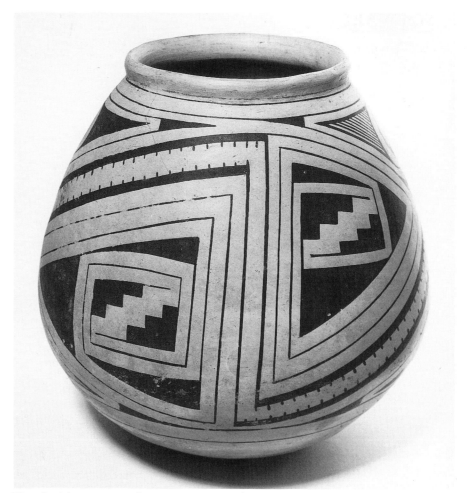

Vessel with geometric design, *Casas Grandes, Mexico*
Painted in slip, burnished and unglazed (Museum of Mankind, London).

CHINESE SLIPWARE

Pottery in China began some time in the fourth millenium BC. In common with early pottery in other countries the first wares were low-fired and unglazed. There are fine examples of decorated pottery from Yang-Shao in Honan Province and Pan-Shan in Kansu, dated around 2000 BC, with beautiful bold decoration painted in swirls of red, black and white slips.

Glazes began to be used in the first millenium BC, and the use of slips died and is scarcely seen in the fine Chinese ceramics until the Sung dynasty (AD 960 to 1279). The north of China was a major stoneware-producing centre, and here in the tenth century they began to make stoneware vessels with slip decoration using sgraffito and painting techniques. This ware takes its name from the region of Tz'u-Chou in Hopei province. The clay varied in texture and colour from grey to buff to white. Over this was put a thick layer of white slip as a ground for the slip decoration, and over that came a glaze which was usually transparent and colourless, though green and later

Fragment of a vase, *Cizhou (Tz'u-Chou) ware, north China, 1000–1200 AD*
The clay body has been covered first with a thick white slip and then a black slip. The decoration was done by sgraffito, using a point and a comb and by carving away larger areas of slip. (British Museum, London).

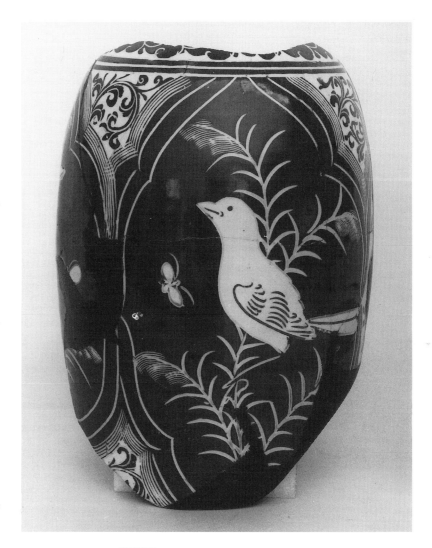

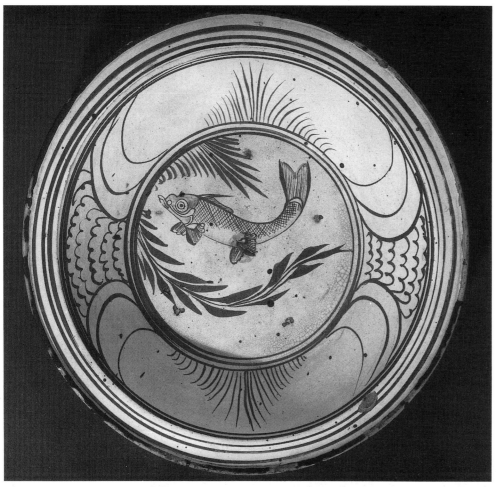

Basin decorated with a fish. *Chinese, possibly from Shaanxi province 12th–14th century* AD. *34 cms diameter. The dish is painted with black slip. (British Museum).*

turquoise glazes were also used. The ware was fired above 1200°C (2192°F).

The sgraffito technique was used from the late tenth century to at least the end of the fourteenth century. The decoration was scratched through the white slip layer to the darker clay body underneath. Excavations at Mi-hsien have revealed pots where a thin layer of an iron-bearing slip was put on the clay body underneath the white slip; this enabled a variation in colour in the incised lines, depending on how deep the sgraffito went. The technique was also extended to carving away areas of slip and clay, creating a decoration in high relief.

Painting on the white slip with black or dark brown slip was a widely-used technique. Designs were often very delicate with stark contrast between the dense black painting and the white background. A whole variety of subjects including floral sprays, birds, animals, and landscapes was used. A combination of painting and sgraffito was also in evidence. A thick layer of black slip was carefully painted on to form the basic decoration and then details added by incising through to the white slip underneath. In another technique using roulettes the pot was first covered in white slip then black slip was brushed on. A roulette wheel (a pattern carved in relief around the circumference) was rolled over the black slip creating white marks wherever it indented.

In the thirteenth century another slip technique sometimes known as 'cut-glazed'

was in use. In reality this was sgraffito through a slip which vitrified on firing. A thick layer of a dark brown slip was put over the grey clay body, and the decoration incised and carved through. The pot was not glazed because the slip had a sufficiently low melting point to melt during firing, forming a glaze that was a rich semi-matt dark brown yet stiff enough not to run and obscure the sgraffito decoration.

GREEK

From neolithic times Greek potters knew about pottery and decoration using slips made from natural clays. Designs were mainly abstract but, during the Minoan civilization in Crete (second millenium BC), wonderful pottery with designs based on natural plant, sea and animal life was being made. The decoration, still in slip and unglazed, was bold and uninhibited, covering the whole surface of the pot and creating masterpieces which are distinctive and unsurpassed for their imaginative use of space.

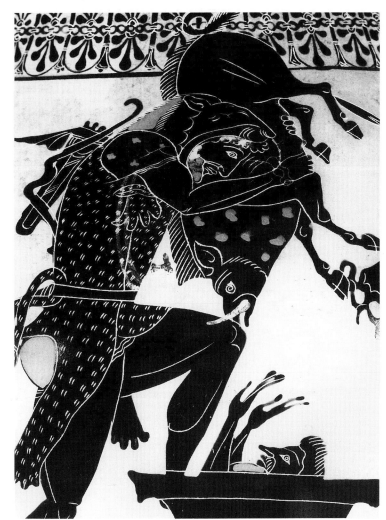

Detail from an amphora. *Greece, sixth century, BC. Black figure decoration on red panels with fine sgraffito.*
The detail shows Heracles and the Erymanthian boar. He is hurling the boar down onto Eurystheus who is hiding in a large pithos sunk in the earth. (British Museum).

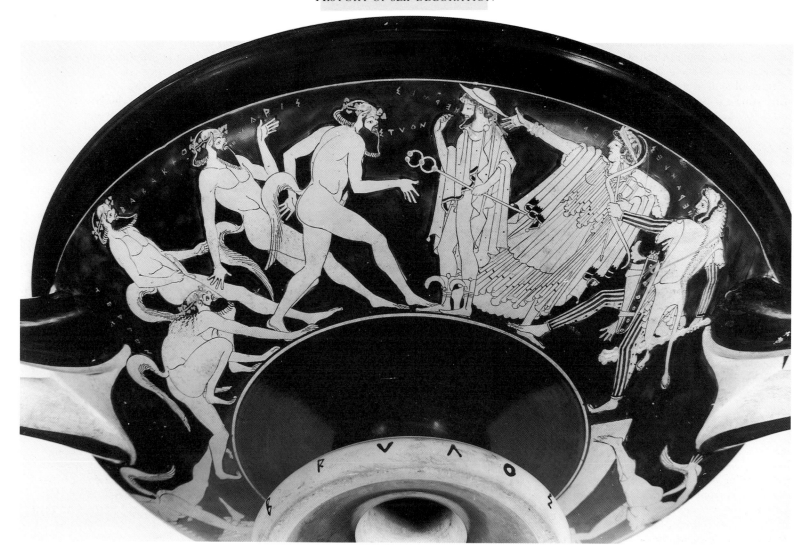

The fabulously sophisticated black and red vases of Athens and Corinth were made between about 750 and 300BC and represent a degree of skill in making, decorating, and firing which is astonishing. Up until the middle of the sixth century BC the decoration was of the technique known as 'black figure': black silhouettes were painted with a brush on a plain red or orange clay ground and details were added by sgraffito. In the sixth century 'red figure' work was developed; here the background was painted black around the figures, which were left red. The details of the figures were then painted in black, enabling much finer and subtler images to be created.

The vases were made on the wheel and, when leather-hard, were burnished and painted with slip and fired only once. Often a yellow ochre was used to intensify the reddish-orange colour of the natural clay. White and purplish-red slips were sometimes used with black in the decoration. The black slip is not a coloured slip but is a refined version of the basic red clay used to make the pots, turned black by the process of reduction during firing. The refining

Part of a kylix (cup). Greece, fifth century, BC. Red figure decoration with background and detailing painted in black slip.
The scene is from a satyric drama. Four Seileni are advancing to seize Hera and are confronted by Hermes. On the right is Heracles. (British Museum).

technique involved separating out and using only the very finest particles in the clay. This process had the effect of increasing the proportion of iron, silica, and fluxes in the slip.

The firing involved three phases. In the first phase an oxidized atmosphere was maintained in the kiln as it was heated up to 800°C (1472°F). Both the clay body and the decoration stayed red. The second phase, 800–950°C (1472–1742°F) was sustained with a reducing atmosphere. In these conditions of lack of oxygen in the kiln, the iron in the clay body and slip (red iron oxide, Fe_2O_3) was converted to black ferrous oxide (FeO). Hence both pot and slip turned black. There is good evidence that they also introduced water vapour into the kiln, perhaps by using green wood. This encourages the formation of magnetic iron oxide (Fe_3O_4) which is even blacker than ferrous oxide.

The kiln was cooled, still with a reducing atmosphere, and then in the third phase cooled from 900°C (1652°F) in an oxidizing atmosphere again. The clay of the pot turned back to red because Fe_2O_3 is a more stable compound than FeO, but the painted slip stayed black because the fine slip had sintered (the iron particles had begun to fuse with silica). The ferrous oxide was thus locked in and could not change back to red iron oxide. The top temperature was fairly critical and depended on the type of clay used: too low, and the slip cannot sinter; too high, and it then becomes open to

oxidation again.

This technique of using reduction to change the surface colour of a pot has been used in many countries and at many times but there is no doubt that the Greeks mastered it to a degree far beyond anyone else. (See the section on terra sigillata for more information on refining slips.)

In the fourth century plain black wares became popular and the techniques of painted figure decoration died out.

ROMAN

The most widespread type of Roman pottery was 'red-gloss' ware, made by dipping the pot in a fine-particled slip rich in iron, similar to the Greek slip, and firing in an oxidizing kiln. This style of pottery appeared in the first century BC around the Aegean. Arretium (Arrezo) was the major centre of production in Italy from 30BC to AD30, where the very finest examples of this style were made. Extensive use was made of moulds with impressed and relief decoration. The figurative designs were classical and restrained. Black pottery was also made by the same process of firing in a reducing atmosphere without oxidizing on cooling.

Other techniques of decoration included carving, incising, and applied relief. Shapes often resembled those of metal forms. The skills of the Romans spread north with their conquests, whilst to the east their empire encompassed countries with their own skills

of glazing, and these too began to spread throughout the empire.

BRITAIN

Pottery had been made in Britain before the Roman invasion, but, as with many arts and sciences, the superior knowledge of the Romans could soon be seen in pottery made after the first century AD. Particularly interesting was the development of slip-decorated wares in the second century at Castor near Peterborough in Northamptonshire. One characteristic style involved coating the pot with a dark slip and trailing a decoration over it in a white slip. The pieces were not glazed. Hunting scenes and gladiatorial combats were favourite themes. Thick slip was also used to create decoration in a relief under the dark slip coating. Production of 'Castor' ware continued until the late fourth or early fifth century AD. The New Forest was another centre of production in Roman times.

Once the Romans left Britain in the fifth century, pottery production declined both in quantity and quality; but it did not die out, and a slow revival began in the ninth century, influenced by the flourishing pottery manufacture in Germany. Decoration, when used, was usually either incised or applied by using coloured clay. In the thirteenth and fourteenth centuries there was a vogue for highly-decorated jugs, which were made all over England with strong regional differences. The jugs were thickly made, often glazed with a green lead glaze and decorated by carving, modelling, or applying coloured clays and slips. Cooking pots, bowls, and all kinds of storage containers were made in clay but almost never tableware such as plates or cups.

The next major change in pottery production began in the sixteenth century when pottery drinking cups and other tableware became more fashionable, perhaps because production techniques had improved sufficiently to make cheaper, better-quality and more durable wares possible. 'Cistercian' ware (so named because it was once thought to have been made by monks in the great monasteries of Yorkshire) represents a marked improvement in the potters' skill. The pottery is mainly cups (tygs) in a wide variety of forms and with two or more handles. They were decorated with trailed slip or applied decoration (either in white clay on a red body or red on white) and covered in a dark iron-brown glaze.

Pottery was being made all over the country. Transport of such fragile ware was difficult, so every region had its local centres. Much of their production was for every-day use of the rural and city poor for cooking and food storage and so was not decorated. Decoration added an extra cost and was reserved for commemorative or special wares.

The first reliably-dated English slipware comes from Wrotham in Kent. Here potters made a wide range of commemorative pottery in red earthenware with white decoration. Initially they used white clay pressed onto the surface, and later they also slip-trailed with white slip. The earliest dated piece is from 1612, the latest 1739. Cups with three or more handles were common and other forms include jugs, puzzle jugs, and candlesticks. The potters obviously took great pride in these pieces for they were often impressed with their own initials, and so it has been possible to identify several different potters.

The seventeenth century was the time in Britain when slip decoration was the pre-eminent form of decoration and when all the now traditional techniques were devised and fully exploited with great skill. Around Harlow in Essex 'Metropolitan' ware was made (originally found and thought to have been made in London). The slip decoration is mostly simple abstract motifs such as wavy lines, dashes, or herring-bone, and sometimes includes inscriptions of a very moral kind in keeping with the strict Puritan thinking of the area.

Castor ware vase, *Nene Valley, Great Britain, 100–400 AD*
This is perhaps the earliest use of slip-trailing in Britain, made during the Roman occupation. White slip has been trailed over a black background slip and fired without a glaze. (British Museum, London).

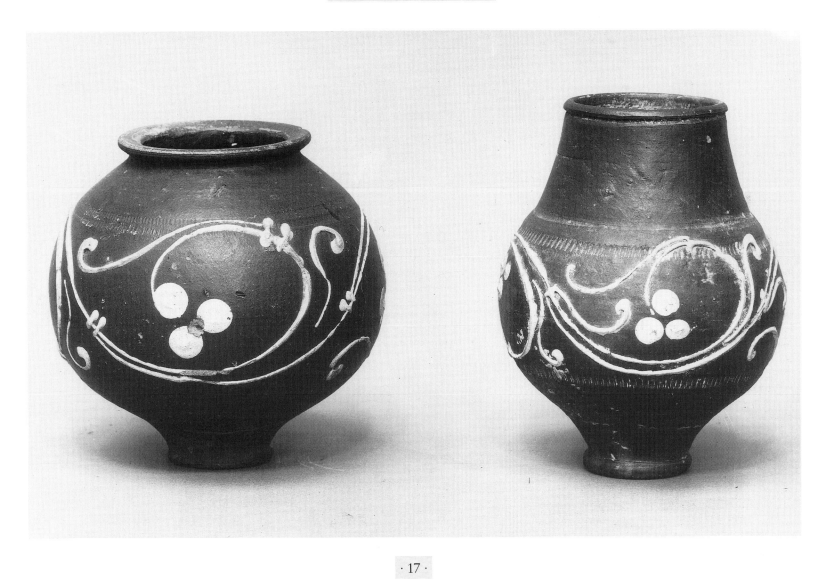

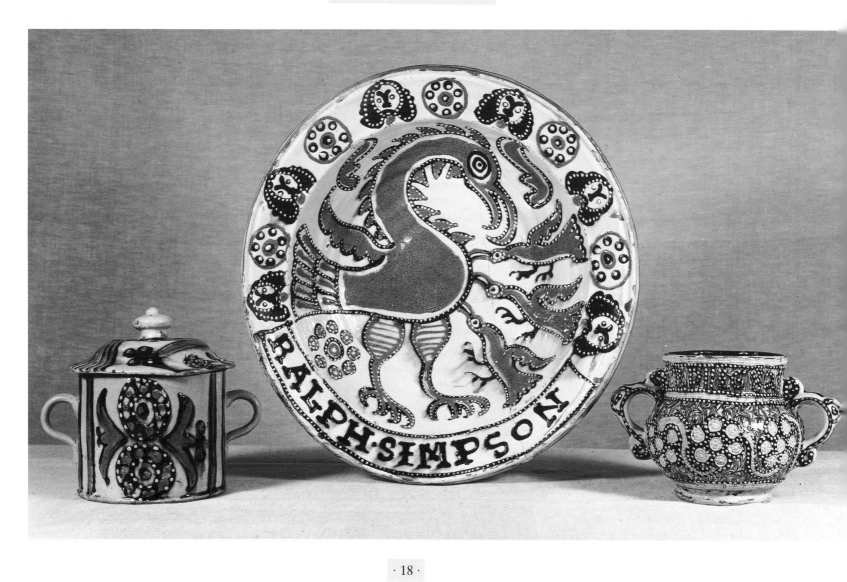

Excellent sgraffito work was being made in various potteries in North Devon, mainly at Bideford and Barnstaple where there had been potteries from at least as early as the tenth century. The pottery was made of red clay covered in white slip and was lead glazed. By the 1650s the standard of decoration had reached a very high level with a great variety of floral and geometric designs. Large quantities were exported to North America. At Donyatt in Somerset was another pottery thriving since medieval times, where slip decoration was in use with sgraffito, slip-brushing, slip-trailing, and combing, all executed with great accomplishment. Other notable potteries were at Tickenhall in Derbyshire and Fareham in Hampshire.

It was in the seventeenth century that the

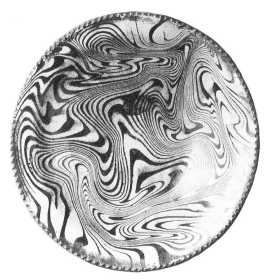

Marbled dish, 13¾ in. (40 cm) diameter, Staffordshire, Great Britain, 1700–1800 AD A beautiful example of marbling on a press-moulded dish in black and white slip with a clear lead glaze. (Victoria and Albert Museum, London).

Staffordshire slipware, *Staffordshire, Great Britain, 1600–1700 AD*
Three examples of slipware made in the heyday of slip decoration in Britain.
Left: *Posset pot and cover 7¼ in. (18.4 cm) high. Slip trailed in black, white and iron-red slip, covered in a clear glaze.*
Middle: *Dish 17 in (43.2 cm) diameter. Slip-trailed in white, black and iron-red, covered in a clear lead glaze.*
Right: *Posset pot. This pot has a marbled background over which slip-trailing and embossed decoration has been added. (Victoria and Albert Museum, London).*

potteries in Staffordshire around Stoke-on-Trent began their rise to pre-eminence. Here they had substantial supplies of clay and, just as important, plenty of coal for firing. This meant that their production costs were low and it made it economical to transport their pottery to other areas of the country. Slip-decorated earthenware was the main kind of pottery produced during this period. Every

kind of pot was produced from cups, bowls, and butter pots to the great slip-trailed plates of Thomas Toft. They used red earthenware clay with a palette of coloured slips, predominantly black, white, and natural red, with a clear lead glaze over them. Slip-trailing was the favourite technique, but sgraffito, inlay, and painting were also used, and the potters made good use of feathering and marbling, particularly on press-moulded dishes.

Inevitably, the production of much higher-quality pottery in other countries – porcelain in China, maiolica in Italy, delftware in Holland, soft-paste porcelain in France – led to the demand for similar ware in Britain, and in the eighteenth century serious efforts were made to produce pottery of comparable quality. In 1759 Josiah Wedgwood set up his first factory in Burslem near Stoke to mass-produce his new high-quality wares, and this led directly to the demise of both the country pottery and slip decoration as a widely-practised art – it simply was not wanted when much more sophisticated pottery was possible. Nevertheless, production continued in various small centres around the country, some continuing into this century (at Burton-in-Lonsdale, Howcans, and Littlethorpe in Yorkshire; Weatheriggs at Penrith, Cumbria; Bideford and Barnstaple in Devon, and Buckley in Clwyd, amongst others).

CONTINENTAL EUROPE

Throughout Europe it seems as if slip decoration was the necessary precursor to the more sophisticated techniques like maiolica, underglaze painting, and enamels. In Italy, France, Holland, and Germany potters became proficient in slip techniques at an earlier stage than their British counterparts and began to explore other techniques much sooner. Slip decoration never completely died out, for maiolica and porcelain could be afforded only by the rich, and simple earthenwares and stonewares continued to be made for the majority in a tradition which in some countries has managed to survive to the present day.

ITALY

Sgraffito (the word itself is Italian) was popular in early Renaissance Italy of the fourteenth and fifteenth centuries. Faenza, Bologna, and Romagna were among the centres of production and many very fine pieces were made with elaborate decoration. A red clay was used, covered in a white slip. Colour (green, purple, or brown) was sometimes painted or often apparently splashed on in a very uncomplimentary way, considering the refinement of the sgraffito work. In the sixteenth century maiolica ware was developed and slip decoration became restricted to country potteries.

GERMANY

In Germany the technique of lead glazing had not really died out from Roman times, and by the medieval period potters were already skilled in throwing, modelling, and relief work. In the lower Rhine area, and at Wanfried-an-der-Wessa in Hesse in the sixteenth century, slip-decorated ware was being made which was exported to Britain and certainly influenced production there.

Trailing and sgraffito were most commonly used with red, black, white, and green slips. The most spectacular pieces are large plates often decorated with religious scenes, farm scenes, and military figures. Iron, manganese, and copper oxides were sometimes painted on to give splashes of colour over the slip. Some modern slipware in traditional style is still made in Germany.

FRANCE

The regions of Normandy, Beauvais, and Poitou were major production centres in France in the fifteenth and sixteenth centuries and slipware flourished there. Very many items of useful pottery were made there including dishes, porringers, jugs, bottles, cups, and drug jars. In the Beauvaisis region sgraffito became the most widely-used decoration in the sixteenth century, although decoration in relief and moulded and impressed wares were also made.

The sgraffito is very distinctive, being finely stylized and unfussy. The designs were usually composed of human figures, plants, birds, and religious motifs; dishes often had this kind of design in the centre with an inscription around the border. One characteristic was the use of a toothed comb to draw broad lines through the slip, giving a contrast with the more usual fine single line. The decoration was drawn through a single layer of slip (white on red clay) or on a double layer (red on white on red). A few potteries working in the old methods have survived in France to the present day.

PORTUGAL AND SPAIN

Perhaps the European countries most well known for simple peasant pottery in modern times are Portugal and Spain. This is only because those countries have, until relatively recently, been so poor and unindustrialized that rural people really needed the country potteries to make pots for their own use. Many of these potteries have now ceased working, but the tourist industry has enabled some to survive, though the high quality of work has rarely been maintained. In Andalusia, Galicia, Extremedura, La Mancha, and Cataluna a great variety of mainly slip-trailed pottery is made, usually in white on red clay with a clear or copper-green glaze over.

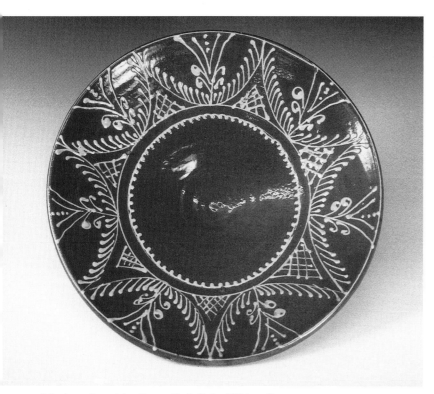

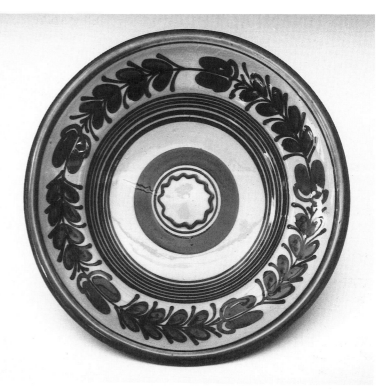

Modern Spanish slip-trailed dish. *White slip on red earthenware with a clear glaze.*

Modern dish from Hungary. *Slip-trailed and brushed in white, black, brown and green slip under a honey glaze.*

HUNGARY

In Hungary, as in other East European countries, there is a strong tradition of hand-made pottery which still survives on a limited scale. Slip-decoration in black, red, white, and green is common, with a clear, honey, or green glaze over. The decoration often combines trailing and brushwork with floral designs executed simply but with great flair.

2 CLAY – THE RAW MATERIAL

Clay is composed of tiny, roughly hexagonal plates, too small to be visible to the naked eye, and surrounded by water. The plates are made of crystals containing alumina (Al_2O_3), silica (SiO_2) and water. Clay is plastic because the water around the plates enables them to move easily in relation to each other, and it is this characteristic plasticity that the potter takes advantage of in making pottery.

The other main characteristic of clay is its durability when dried and fired. The firing process gives permanence to the raw clay, driving off not just the water around the plates but also the water chemically combined with the alumina and silica. It is an irreversible process, fusing the particles together to make a material that is strong enough to last thousands of years – the archaeologist's dream.

There are many natural clays that can be dug straight from the ground and used as they are, though some refining is probably needed if they are to be used in quantity. It is worth experimenting if you see a vein of clay in your garden or on a walk by digging some up and trying it out. Test how plastic and easy to use it is, and fire a little to see what colour it becomes and at what temperature it begins to vitrify. The onset of vitrification (when a clay matures) is an important characteristic of every clay, for it makes the clay stronger as well as improving the *fit* of glazes and reducing crazing.

The fit of the glaze is the measure of how well the expansion rates of glaze and clay body match each other when heated or cooled. If during firing the glaze expands a lot more than clay, then crazing of the glaze will result. If the body expands more than the glaze, it is possible in extreme cases for the glaze to 'shell off'. Ideally, the best glaze/body fit is when the glaze is slightly under compression – that is, when the expansion rate of the body is slightly greater than that of the glaze.

Clays fired to temperatures well below vitrification are soft, very porous, and fragile. As the temperature increases the clay gets harder, less porous, and stronger. Vitrification occurs when the clay particles are completely fused together and porosity is nil. Above that temperature, the clay begins to melt and becomes brittle in the cool state. Clay is usually strongest when fired slightly below vitrification.

DIFFERENT TEXTURES

Red clays, some stonewares, ball clays, fire clays, and china clay are all natural clays. There are many industrially-produced clays too – careful blends of natural clays and other minerals like flint and feldspar – so that modern potters have a wide variety of clays at their disposal with different colours, textures, and firing temperatures. White earthenware, porcelain, and bone china are all mixtures of clays and minerals.

Clays which are fine-grained and smooth are excellent for making small pots, pieces with fine details, thin delicate pots, and for pots that are thrown and then turned. The disadvantage of them is that water vapour does not escape easily during firing, and so thick ware must be fired slowly to prevent cracking. Joining pices of clay can also be tricky unless they are at the same state of wetness because otherwise they dry and

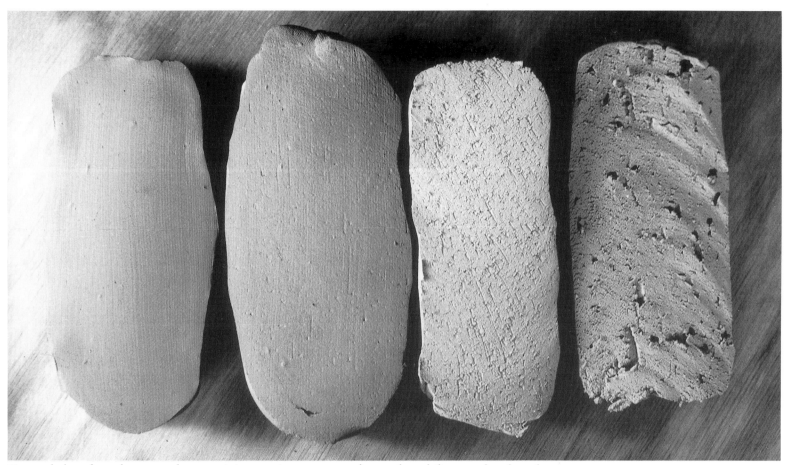

Grogged clay, *four clay examples containing varying amounts of grog, from left: smooth red earthenware, ideal for throwing and fine detail; St. Thomas oxidized, a good general purpose stoneware clay; T-material, a clay that is excellent for large and awkward sculptural pieces; sculpting marl, very heavy grog for large thick pieces.*

shrink at different rates and are likely to crack apart as they dry.

Coarse-grained clays are very suitable for making large and thick pottery. The large grains may be fire clay or grog (previously-fired, crushed clay) and they open out the clay making it easier for water vapour to escape when drying and in firing. It is also much easier to join pieces of clay without cracking.

STONEWARE

Stoneware clays are generally considered to be those that mature over 1200°C (2192°F). Above that temperature the glazes have a similar composition to the clay so that body and glaze integrate and there is no clear dividing line between the two. The body is normally vitrified, non-porous, and very strong (hence its name). The clays have good plasticity and usually a moderately coarse texture so that they are easy to work with on both large and small objects. They are suitable for hand-building, including coiling and slab-building, and for throwing. In Britain, the most common stoneware clay is St Thomas's, but there are many others made for either oxidation or reduction and in a range of colours from dark brown to grey to almost white. Many potters like to mix their own stoneware from ball clays, fire clay, and sand.

EARTHENWARE

Earthenware clays fire below 1200°C (2192°F). The most common are red earthenware, which matures at about 1060–1120°C (1940–2048°F), and white earthenware – 1120–1190°C (2048–2174°F). The red is a smooth clay, easy to work with, suitable for hand-building, throwing, and moulding but not for working large pieces unless grogged. White earthenware is also very smooth but not at all easy to use unless you are press-moulding or casting. It is difficult to join pieces without cracks occurring, and it has little plastic strength to stand up to the stresses of throwing. Most manufacturers now market a white throwing earthenware that is much easier to use because it contains more ball clay, but it is not quite so white. Earthenware is, usually, a little porous and not as strong as stoneware.

PORCELAIN

Porcelain is prized for its whiteness and translucency. It is not a naturally occurring clay but is made of china clay, feldspar, and flint. The translucency is only apparent on thin-walled pots. Because it does not contain any really plastic clay, porcelain is very difficult to work with, cracking easily when distorted and with very little internal strength. The best techniques to use are press-moulding and slip-casting. Thrown pots are best made thick and then turned thin. Porcelain is normally fired to vitrification point (1280–1320°C [2336–2408°F]) and has a high shrinkage. In oxidation it is a creamy white colour; in reduction it is white tinged with blue or grey.

RAKU

Raku is not a clay but a process of firing for which a specially-prepared clay is an advantage though not a necessity. Raku clay is very coarse to withstand the high stresses undergone in firing and cooling. The usual firing range is 750–1050°C (1382–1922°F). It is very good for all the hand-building techniques, though it can be thrown if you have iron-clad fingertips.

3 SLIPS

PROPERTIES

Slip is any mixture of clay and water that has been sieved to a smooth consistency. This book is about slip decoration, so in this section only slips suitable for applying to the surface of a pot will be considered.

The main ingredients of a slip are clay and water, but other materials can be included to modify the properties of the slip to meet special circumstances. Any clay can be used, too, but there are some considerations to be taken into account before mixing up a slip.

The main difficulty a potter faces when using slip is its 'fit' to the surface of a pot. As clay dries, and also when it is fired, it shrinks. Some clays shrink more than others, depending on their capacity to contain water (more water means higher shrinkage in drying), and on the firing temperature (the higher the temperature the greater the shrinkage during firing). If the clay used for the slip has a significantly different shrinkage rate to the clay used for the body, there is a serious risk that the slip will flake off at some point during drying, firing, or even

months after it has been glazed. The same can happen if the slip is applied when the pot is too dry, for the slip will shrink more than the pot as it has to dry more.

The colour of the slip is important. Body stains and oxides are used to stain a slip but they can only add colour and make it darker – they cannot be used to lighten or brighten a slip. To get lighter shades it is necessary to use a white slip as a base.

USES

Slip is often used to modify the surface texture of a pot, and this is particularly crucial if no glaze is to be used and the surface is to be burnished or polished. The slip needs to be composed of very fine particles that will give a very smooth surface (*see* Terra sigillata page 28). Conversely, it is also possible to use a slip to give a very irregular, rough surface by including larger particles like grog in the slip.

The best clay to make into a slip is the same clay that has been used for the pot it is to decorate. This immediately overcomes the whole problem of fit between body and slip (as long as it is put on before the pot is too dry). A simple clay and water mixture will be sufficient and, if desired, you can sieve it to remove any sand, grog, or other large particles, thus giving a smoother surface. If you are using a whitish clay then there is no difficulty in staining it with oxides and getting a wide range of colours.

If using the same clay for slip and body is inappropriate, perhaps because the colour is wrong, then you must consider using another clay for your slip – one that has the same or slightly less shrinkage as the clay body. Although it is possible to measure the shrinkage of clays, it is probably just as easy to match slip to body by a process of trial and error.

A versatile slip can be made using china clay and ball clay or even ball clay on its own. China clay, the purest natural clay, is very white, contains few impurities, and is very refractory (vitrifying at about 1770°C [3218°F]). Its large particle size means that it holds relatively little water when in slip form and so has very low shrinkage. On its own it

would be unsuitable for use as a slip.

Ball clays, like most natural clays, are the result of hundreds of millions of years of weathering of china clay, and have been distributed far and wide by rivers and seas. Nevertheless, they are purer clays than those like red earthenware. Ball clays vary greatly in the amount of impurities, like iron, and in the proportion of silica they contain. They are all highly plastic, have small particle size, high shrinkage, and vitrify in the range 1100–1300°C (2012–2372°F). Because of the impurities they have picked up, ball clays do not fire white but most fire to a creamy colour. A greater proportion of iron will turn the colour darker.

A good all-purpose and almost white slip can be made with a combination of 40 per cent china clay and 60 per cent ball clay. For such a simple recipe it is surprisingly versatile. It can be used on red and white earthenware, stoneware, or raku. The choice of ball clay to use is fairly wide as long as it has a low iron content and is high in silica. Two that work well are Hyplas 71 and DBG (available from good pottery suppliers). Both of these fire fairly white. The proportion of china clay to ball clay can be varied depending on the amount of shrinkage required. More china clay means less shrinkage; more ball clay increases shrinkage.

Other additions to the slip are: flint or quartz to reduce shrinkage in firing, harden the slip and give a better glaze fit; zirconium silicate to act as an opacifier; and flux to harden the slip, improve adhesion to the body and increase shrinkage in firing. A suitable earthenware flux is a borax frit whilst at stoneware temperature cornish stone or potash feldspar with a little whiting would be appropriate.

Very often it is not until after a pot has been glazed and fired that slip and glaze begin to flake off or shiver. The glaze creates a strong tension at the surface as it contracts after firing, and if the slip/body adhesion is poor then the glaze will pull the slip off with it. This occurs commonly on rims and sharp corners, and in such cases is most likely to be because those parts of the pot had dried out too much when the slip was put on.

PREPARATION OF SLIP

It is easy to mix dry clay with water to make into a slip but almost impossible to turn wet clay into a slip. If you are making a slip with a clay body, therefore, you should first of all dry it out completely and then break it up into small, walnut-sized pieces so that it breaks down easily when in water.

If your slip contains several different ingredients, weigh them out in the correct proportions when dry. Put a little water into a suitably-sized container and add all the dry ingredients. Add more water just to cover and leave until everything has slaked – a few hours or until the next day – though if you are in a hurry, powdered materials *can* be mixed into a slip immediately.

The slip must be sieved to divide the lumps into fine particles and to mix the ingredients properly. It is easiest to sieve twice, first through a 60's mesh and then through a 100 or 120. If you are using body stains or oxides and want an even-coloured slip without speckles then it will be necessary to sieve them through a 200 mesh by first mixing with a little of the slip then sieving and stirring into the rest of the slip very thoroughly.

The consistency of the slip depends entirely on how it is to be used and is best judged by experience. If a slip is too thin then allow it to stand for a day or two to settle, and decant off some of the water at the top. A quicker, though more laborious, way is to dry out some slip on a plaster slab and then sieve it back into the main bulk of the slip. A flocculant like calcium chloride can also be used – add just a few grains dissolved in a little hot water and stir well.

POTTERS' RECIPES

CLIVE BOWEN
On red earthenware fired to 1060°C (1940°F) in a wood kiln:
White slip:
Peters Marland stoneware clay sieved through 120 mesh sieve
Red slip:
Own clay dug from a nearby field (vitrifies at about 1200°C [2192°F])

Black slip: %
Fremington clay 80
Red iron oxide 10
Manganese dioxide 10

PETER DICK
On red earthenware (Potclays 1137M) fired to 1220°C (2228°F) in a wood kiln:
White slip:
HVAR ball clay 100%
Black slip:
Red clay slip 30 litres (53 pt)
Manganese dioxide 720 gm (25½ oz)
 dry weight
Red iron oxide 360 gm (12¾ oz)
 dry weight
Purple iron oxide 360 gm (12¾ oz)
 dry weight
Buff/gold slip:
Potclays Buff body 1120
Other coloured slips made with HVAR ball clay with oxides.

SHEILA CASSON
On porcelain or white stoneware 1280°C (2336°F) reduction:
Vitreous iron slip: %
Cornish stone 60
Ball clay 35
China clay 5
Red iron oxide 100
Red clay 200
Blue slip (added to 100 parts white slip):
Red iron oxide 6
Manganese dioxide 3
Cobalt oxide 1

MIKE LEVY
On mixed red/white earthenware 1120°C (2048°F) biscuit; 1080°C (1976°F) glaze:
Coloured slips based on: %
China clay 40
Ball clay SMD (Fordamin) 60

ANTHONY PHILLIPS
White slip suitable for stoneware fired to 1280°C (2336°F):
 %
Potash feldspar 35
Ball clay 35
China clay 15
Flint 20
These proportions can be varied quite widely without ill effect. The following recipe is also effective:
 %
Potash feldspar 22.5
Ball clay 28
China clay 28
Flint 22.5

SLIP FOR DRY AND BISCUIT WARE

Although slip is traditionally a technique used on a wet to leather-hard clay surface, it is just as feasible to use it on a dry clay surface or on a fired surface. The composition of the slip will, however, be different, for the shrinkage of the slip must still match that of the body, and if the body is already dry or has been fired then it is not going to shrink much, if at all, in the next firing. It is also important for the slip to adhere well to the clay body, so it may well need to contain some flux.

To reduce shrinkage the slip should contain a good proportion or entirely calcined clay (powdered clay that has been fired to about 1000°C [1832°F]). As a flux to help adhesion, a borax frit can be used at earthenware temperatures and a feldspar at stoneware temperatures.

SLIP RECIPES FOR USE ON DRY OR FIRED CLAY
For earthenware: %
Calcined ball clay 35
Calcined china clay 25
Borax frit 20
Flint 20

For stoneware: %
Calcined ball clay 35
Calcined china clay 25
Cornish stone 20
Flint 20

TERRA SIGILLATA

This is a name given to Roman pottery on which an extremely fine-particled slip was used to coat the surface of pottery, giving a high red sheen without a glaze. Although any clay surface can be burnished to give a polished shiny surface, the effect can be greatly enhanced by using a terrasigillata slip. The Romans used a red clay slip from which all but the finest particles had been removed, and they achieved beautiful earthy red colours; but the same process can be applied to any clay. Although this process was used by the Romans, it was invented by the Greeks centuries before, and, quite independently, the pre-Columbian potters of the Americas were also well-skilled in such techniques.

The best way to remove the coarser particles in a slip is by sedimentation. Clay in water takes a long time to settle, for the particles in suspension attract each other, and the larger ones are prevented from dropping down without the smaller ones. It is not a very efficient way of separating out the different sizes. However, a small amount of deflocculant added to a thin slip will have the effect of retaining the smallest particles in suspension whilst allowing the larger particles to fall to the bottom. Sodium carbonate or soda ash, sodium hydroxide, or sodium silicate can be used as a deflocculant, and only a very small amount, about 0.3 per cent by weight, is needed.

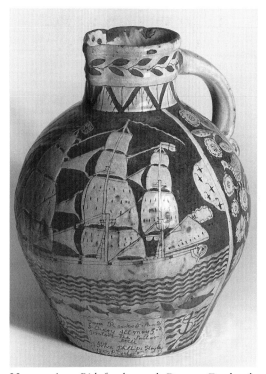

Harvest jug, *Bideford, south Devon, England, 1857.*
The tradition of sgraffito through a white slip to reveal the red clay body underneath lasted well into the nineteenth century, as this jug shows. It is inscribed 'From Rocks and Sands and Every Ill May God Protect The Sailor Still John Phillips Hoyle 1857 Bideford'. (Fitzwilliam Museum, Cambridge).

Dissolve the deflocculant in a small amount of hot water and add it to the rest of the water, then mix in the powdered clay, sieve, stir thoroughly, and leave to stand for two days in a tall container. Pour away any water at the top then pour off and keep the middle layer and discard the bottom layer containing the largest particles. To thicken the slip to a more useful consistency add a few grains of calcium chloride dissolved in a little hot water and sieve again.

SLIP RECIPES FOR TERRA SIGILLATA

1. 500 gm (18 oz) dry clay, powdered
 1.5 gm (0.05 oz) sodium silicate
 1 litre ($1\frac{3}{4}$ pt) water

2. 115 gm (4 oz) clay
 2.5 gm (0.1 oz) sodium hexametaphosphate (Calgon water softener)
 $\frac{1}{2}$ litre ($\frac{7}{8}$ pt) water

4 COLOURS

Slips can be coloured with either metal oxides or industrially-prepared body stains. The range of colours is fairly wide but a great deal also depends on firing temperature, glaze composition, and kiln atmosphere (oxidation or reduction). Blues, yellows, and browns are easy to obtain; there is a reasonable range of greens and pinks, but good reds are generally very difficult.

OXIDES

Metal oxides are the basic raw material for making colours in ceramics. Although there are quite a few that could be used, many are scarce and expensive and are not available to the craft potter, though some like cadmium, selenium, iridium, and praesodymium are used industrially in the production of stains. Oxides, whether in slip or glaze, give much more varied results than do body stains. Firing temperature (even 30°C [54°F] difference can be noticeable), glaze composition, and glaze thickness can make a substantial difference to the colour produced (generally the higher the temperature, the

darker the colour).

Oxides are not ground as finely as body stains and can give a pronounced speckle in slips. This effect can sometimes be more pleasing than the consistently uniform colour of a body stain. Some oxides behave as fluxes and can float into the glaze – this can be a very beautiful but not always a very welcome effect. Most oxides, if used in excess, will give black or near black results, whereas body stains can go no darker than their own colour. Glazes over a slip always make the colours darker and stronger, much as if the pot has been dipped in water, and some oxides, such as copper, need a glaze in order to bring out their colour. Few oxides have the same colour raw and fired, and some are completely misleading: cobalt carbonate is pink and fires blue: copper oxide is black and fires green.

When talking about percentages of oxides or stains in a slip, glaze, or body, the normal practice in pottery is to refer not, in fact, to the true percentage but to an addition of that amount to 100 per cent of slip, glaze, or body. For example, a slip with 8 per cent

copper carbonate means 100 gm ($3\frac{1}{2}$ oz) of slip ingredients plus 8 gm ($\frac{1}{5}$ oz) of copper carbonate, making a total weight of 108 gm ($3\frac{7}{10}$ oz), of which 8 gm ($\frac{1}{5}$ oz) is not, of course, 8 per cent, but 7.4 per cent. Percentages always mean percentages by weight of dry ingredients, not volume.

The elements generally available to the potter are:

Antimony	–	yellows
Chromium	–	greens, yellows, pinks (at low temperatures)
Cobalt	–	blues
Copper	–	greens, reds (in reduction), turquoise, pink
Iron	–	browns
Manganese	–	purples and browns
Nickel	–	greys, pinks and purples
Tin	–	white
Titanium	–	white
Vanadium	–	yellows
Zirconium	–	white

ANTIMONY

Antimony is available as antimony oxide, Sb_2O_3. In combination with glazes containing lead it gives yellow, and with iron oxide orange can be produced. In a leadless glaze it gives a nondescript colour, so it is most useful at earthenware temperatures when used with lead. Use 5–20 per cent by weight in a slip, and remember that it is poisonous.

CHROMIUM

Chromium oxide, Cr_2O_3, is a dark green colour and is a strong colouring oxide; even 2 per cent in a slip will give a dense dark green and further additions of oxide will scarcely alter the colour. It gives a characteristic rather dull green in most conditions, at earthenware and stoneware temperatures and by oxidation and reduction. It is equally effective in a slip without a glaze.

Use a half to 5 per cent by weight in a slip. A much more attractive blue-green can be obtained if Cr_2O_3 is used in combination with cobalt, but for this use half as much cobalt as chrome. In combination with iron oxide, a grey green slip results; with manganese or nickel, a khaki green is produced. In very small amounts it gives pinks in glazes that contain tin oxide.

COBALT

Cobalt is available in two forms – cobalt oxide, Co_3O_4, which is black in its raw state, and cobalt carbonate, $CoCO_3$, which is pink.

Cobalt produces very strong rich blues, even a half per cent in a slip will give a pale blue and 5 per cent will give almost black. Cobalt oxide is stronger than cobalt carbonate – roughly two parts of the oxide in a slip will produce the same strength of blue as three parts of the carbonate. The oxide particles are larger and give more speckle.

Cobalt is a flux even at earthenware temperatures and will bleed into the glaze. On high-fired biscuit-ware, a cobalt slip will be more vitrified and so harder to cover with a glaze. Cobalt is equally effective during oxidation or reduction, and at stoneware temperatures even less is required: 1 per cent will give a strong blue. It gives blue in slips without the need for a glaze covering, though higher concentrations will be needed.

By combination with other oxides, cobalt blue can be modified to give a whole range of blue shades. A mixture of iron oxide and cobalt gives grey-blues; with copper oxide and with chromium oxide blue-greens; with nickel, attractive and bright grey-blues; with manganese grey-blues, and with rutile a warm blue.

COPPER

There are two forms of copper used by the potter: copper oxide, CuO, is black and copper carbonate, $CuCO_3$, is pale green. Copper produces attractive greens in most glazes: yellow grass greens under a lead glaze, bluish greens under a borax glaze, and a variety of greens under oxided stoneware glazes. Under alkaline glazes at all temperatures, copper gives brilliant turquoise in oxidation. In reduction copper can give a blood red in certain circumstances: for instance if you use an alkaline glaze that also contains borax and calcium and a slip containing 1 per cent or less of copper. Under other reduction glazes the colour is likely to be more of a muddy brownish-red that can be very unattractive.

Copper oxide needs a glaze in order to achieve its full colouring potential: an unglazed slip containing 2 per cent copper oxide is a pathetic pale grey-green, whereas with a lead glaze it is a bright grass green. At higher concentrations without a glaze it becomes a murky grey or black. The carbonate is not quite as strong as the oxide, but both are strong colourants. Under a lead glaze 2 per cent copper oxide in a slip gives a pleasant grass green, 8 per cent a dark, almost black, green. Under an alkaline earthenware glaze 4 per cent gives a very vivid turquoise, but at stoneware temperatures similar or slightly lower concentrations will be sufficient. Copper is a very strong flux and even at earthenware temperatures will float out of a slip and spread into the glaze above like a cloud. At higher temperatures it is even more volatile and can affect the colour of neighbouring pots, especially in reduction firings. In combinations with iron oxide or rutile, copper oxide gives yellow-greens, with cobalt, blue-greens.

Copper oxide is a dangerous material to use with a lead glaze if the pottery is likely to be used for foodstuffs. It makes the lead much more soluble, even when lead frits are used, so that any food or liquid in contact with the glaze will absorb lead much more readily. Never use copper in a slip under a lead glaze where it could come into contact with food.

IRON

Iron comes in several forms. Red iron oxide, Fe_2O_3, is the most common, but other varieties used by potters are black iron oxide, FeO, purple iron oxide or crocus martis, Fe_2O_3. FeO. $FeSO_4$, and iron spangles, Fe_3O_4. In addition, all the earth colours such as yellow ochre and umber contain iron in varying amounts together with other minerals like calcium which will modify their colouring effect in slips and glazes. Iron gives a wide range of browns in oxidation from red-browns to yellow-browns and from tan to black, depending on concentration and glaze. In reduction greys, greens, brown, and black are possible, and in high concentration rust-red. In combination with other oxides it tends to grey their brightness, and with care some some attractive and subtle shades can be achieved. Interesting results can also be obtained in combination with commercial stains.

Red iron oxide in oxidation is neutral as a flux; in reduction it is a flux. It gives buff to dark brown or black in concentrations of 2–40 per cent in a slip. Alkaline glazes give more reddy-browns, lead glazes more dull browns. The colour of the slip without glaze is reddish and almost as intense as under a glaze. In stoneware oxidation lower concentrations will give similar hues. A slip high in iron (10–15 per cent) under a tenmoku glaze which contains 5–10 per cent iron can give a beautiful speckled rust-red which is especially effective as a contrast to the black tenmoku glaze. Good reduction is also necessary in the firing. Under a lime glaze in reduction olive greens are possible with low amounts of iron (1–4 per cent).

Black iron oxide gives greys to black. Under an earthenware glaze 4 per cent in a slip gives pale grey, 16 per cent dark grey. Unglazed it is almost as dark and has an intriguing purple tinge to the grey. It fluxes at stoneware temperatures.

Purple iron oxide, or crocus martis, can be thought of as a mixture of ferrous sulphate with red and black iron oxides. It is used mainly at stoneware temperatures. It is similar in colour to red iron oxide but has a slightly cooler tone.

Iron spangles is a different crystalline form of iron oxide. It is very hard and has a particle size larger than the other oxides, so it is often used to give a speckle to a slip or glaze. On its own in a slip it gives a pale speckled grey colour at 8 per cent concentration, dark grey at 30 per cent.

IRON CHROMATE

This is a compound containing iron and chromium with the formula Fe_2O_3. Cr_2O_3. It gives greys to black in concentrations of 4–30 per cent in slips under an earthenware glaze, and paler colours without a glaze. Similar colours at lower concentrations are possible at stoneware temperatures. In combination with other oxides, it contributes a greeny-grey that gives the result a murky colour.

MANGANESE

Manganese comes in two forms: manganese dioxide, MnO_2, a black powder, and pink manganese carbonate, $MnCO_3$. Both give the same colours but the carbonate is finer and gives a less speckled colour at earthenware temperatures. Manganese gives shades of purple and brown.

At earthenware temperatures under a lead glaze manganese gives brown: 4 per cent concentration in a slip gives buff, 20 per cent dark brown. Under an alkaline glaze it gives pinky-browns verging towards purple, especially at higher concentrations of 10 per cent and above. Without a glaze it gives slightly paler browns with a hint of grey.

At stoneware temperatures manganese fluxes, and in reduction it tends to volatalize, giving browns and pinky-browns. Interesting blues can be obtained with manganese and cobalt, but with other oxides manganese is not dominant and tends to grey their colour. For example, with cobalt grey-blues, nickel grey-beige, vanadium beige-yellow.

NICKEL

Nickel oxide, Ni_2O_3, is used to give greys. It is a weak colouring oxide at earthenware temperatures. Without a glaze 8 per cent gives a pale greeny-grey, and 30 per cent gives a mid-grey-green. Under a glaze the colours are darker, with about half the amount needed to give the same colour. A lead glaze gives from beige at 4 per cent to khaki at 30 per cent; under an alkaline glaze the colours are more grey. At stoneware temperatures nickel gives various browns, greys and pinks and violets in oxidation. Nickel can be useful in combination with other oxides: with cobalt it gives grey-blue, with copper grey-green, with iron, manganese, and with chrome, browns.

VANADIUM

Vanadium pentoxide, V_2O_5, gives yellows. Without a glaze 8 per cent in a slip is needed to give a pale lemon yellow; 30 per cent gives a darker greener yellow. Under a lead glaze it gives a pale lemon yellow with about 15 per cent. Vanadium is also effective at stoneware temperatures and gives pale yellows at similiar concentrations.

RUTILE

Rutile is a natural ore consisting mainly of titanium dioxide with a small amount of iron. In slips it gives pale orange (10 per cent) to a light orange-brown (30 per cent) without a glaze, and slightly darker shades with a glaze over. It has a good effect generally on the colours of other oxides, making the colours warmer and softer.

BODY STAINS

Body stains are industrially-produced colours based on oxides. They are made by blending oxides with fluxes, clay, silica, and other modifying materials, then calcining to a high temperature and grinding to a very fine powder. The finished product is a stain that is refractory (depending on the amount used), disperses easily into a slip causing little speckle, and is fairly stable in colour despite the temperature it is fired to or what glaze is used with it. (NB Some do burn out at higher temperature.) They give good reliable colours but need handling well to obtain exciting results. One great advantage of body stains is that they are coloured in their raw state to look like their fired colour, so it is much easier to assess roughly what the finished result after firing will be.

The colour range is wide: deep blues based on cobalt; pale blues based on zircon and vanadium; pale pinks based on manganese or chrome and tin; darker pinks based on iron and zircon; light greens based on zircon and vanadium; darker greens based on chrome; yellows based on antimony or praesodymium, and browns based on iron. The colours are usually intermixable, so that intermediate shades are possible. Most can be fired to 1300°C (2372°F) without the colour burning out, and most can be fired in both oxidizing and reducing atmospheres.

Suppliers normally say if there are restrictions with regard to temperature or the use of a particular stain. None of the stains contains copper so they can be used freely with lead glazes. Normally about 10 per cent of a body stain by weight in a slip will be enough to give a good colour, but the amount can be increased up to about 30 per cent to give slightly darker colours. Higher concentrations will produce a slip that is highly refractory, will not adhere to the clay body so well, and will not accept glaze over it easily (the glaze is likely to crawl).

USE OF GLAZE STAINS IN SLIPS

Although glaze stains are not intended for use in slips or clay bodies, some of them can be used quite successfully in slips; if you do so the range of available colours is increased. Their colour in slips may be more muted or dull than in a glaze because some materials are affected by the presence of too much silica or alumina, but it is certainly worth trying. Higher concentration of glaze stain will be needed in a slip (15–20 per cent as an average) because slips are more opaque.

PREPARATION OF COLOURS

All oxides and body stains should be sieved before being added to a slip, unless you deliberately want the high speckle and

uneven staining that result from not sieving. This is really a matter of aesthetic judgement of what is right for the pot. Body stains are very finely ground and easy to disperse into a slip to give a very even colour. Some oxides, particularly cobalt oxide and manganese dioxide, are relatively coarse and even sieved through a 200 mesh will still give a noticeable speckle. Cobalt carbonate and manganese carbonate are finer and give less speckle.

If a really even colour is needed then the oxide should be ground in a pestle and mortar first. Mix the oxide with a small amount of water to make a paste and grind thoroughly for several minutes.

Oxides and body stains should be sieved through a 200 mesh sieve, but the slip itself need be sieved through only a 100 or 120 mesh. Sieve the basic slip first then put some in another container and mix in the stains or oxides. Sieve this through a 200 mesh into the main slip container and stir thoroughly before use.

COLOUR TESTS

Pottery is an unpredictable art. Even if you are meticulous about mixing up slips and glazes to the exact recipe, there is still plenty of scope for variation. The thickness of slips and glaze, firing temperature, and position in kiln can all make a difference. In fact, much of the excitement of pottery is testing and discovering new colours and textures and then using them. Whether you have a particular colour in mind that you want to

get, or you want to see what happens when you combine various materials together, it is usually best to do a series of tests, trying out different proportions of the materials together in a line blend (see below). Avoid the temptation to do a lot of tests at one go – the chances of getting exactly the right result are small and it can be very tedious – but do a few tests that cover the whole range of possibilities to narrow down the options and then repeat the process over a small range that covers the most promising results of the first set of tests.

A line blend is a simple way of testing because you take a few basic recipes and then mix by volume (a teaspoonful each perhaps) rather than weighing out every combination separately. You can test the effect of combining two different oxides in varying proportions by starting off with one slip, A, containing, say, 12 per cent (by weight) red iron oxide, and another slip, B, containing, say, 6 per cent cobalt carbonate. Make sure each slip contains an equal amount of water. Make sure each slip contains an equal amount of water. The line blend is done by mixing teaspoonfuls of A and B in a variety of combinations. Start by taking 1 teaspoon of each, and mix them together. This mixture is composed of one half A and one half B, and the percentages by weight of the oxides would be $\frac{1}{2} \times 12\% = 6\%$ of red iron oxide, and $\frac{1}{2} \times 6\% = 3\%$ of cobalt carbonate. Three teaspoons of A and 1 teaspoon of B means

that three quarters of the mixture is made from A, giving a percentage of $\frac{3}{4} \times 12\% = 9\%$ with iron oxide, and one quarter is made from B, giving a percentage of $\frac{1}{4} \times 6\% = 1\frac{1}{2}\%$ cobalt carbonate.

The following chart shows some of the different ratios of A to B you can have for your final mixture and the consequent percentages of oxide present.

Volume by parts where A contains 12% Fe_2O_3 and where B contains 6% $CoCo_3$	Oxide content expressed as % by weight of final mixture of A and B	
	Fe_2O_3	$CoCo_3$
1 part A only	12	0
3 parts A to 1 part B	9	$1\frac{1}{2}$
2 parts A to 1 part B	8	2
1 part A to 1 part B	6	3
1 part A to 2 parts B	11	4
1 part A to 3 parts B	3	$4\frac{1}{2}$
1 part B only	0	6

Different concentrations of just one oxide or stain can be tested in the same way by using the oxide as slip A, and a plain slip without the oxide or stain as slip B.

Several stains can be tested in combination by preparing each one separately into a slip and mixing pairs or threes together. Note that an oxide may be at a concentration of 12 per cent on its own but when mixed in equal volumes with another its concentration in the combined slip will be 6 per cent, and if mixed with two others its concentration will be 4 per cent.

5 DECORATING WITH SLIP

DIPPING AND POURING

Dipping and pouring are both ways of getting a thin uniform layer of slip onto all or part of a pot. The choice of which to use depends on the area to be covered, the shape and size of the pot, and the decorative effect to be achieved.

You may simply want to cover a pot with slip in preparation for some other decorative technique such as sgraffito, but consider also the effects you could obtain by more imaginative uses of the dipping and pouring processes. Try selectively dipping parts of a pot in the same or different slips, or building up layers of thin slips of different colours. Use different containers like jugs, ladles, and spoons to pour on the slip. With a little practice you can get good control of the process and achieve surprising results.

Whatever method you use you will need to mix up some slip and pour it into a bucket or similar container which is large enough to contain the pot with at least 5 cm (2 in) spare all round. The consistency of the slip will depend on whether you want a thin semi-opaque layer which allows the colour underneath to show through, or a thicker opaque layer that covers everthing. Covering a dark background with a light-coloured slip (or a light background with dark slip) will require a thicker slip. Generally, however, the slip should be of a consistency of anything between single and double cream, but you will have to experiment until you get the results you like.

How much slip you need depends on the size of the pot and the area to be covered. You will need more slip for dipping than pouring – enough to immerse the whole pot if you want to slip the whole surface and this may not be economical if only one or two pots are to be dipped. On the other hand, dipping is a much quicker and less fiddly process than pouring.

Work on only one surface at a time and never slip the inside and outside of a pot at the same time. Slip contains a high proportion of water, and as this soaks into the leather-hard pot it makes it very soft and weak, so covering both the inside and outside at the same time will almost certainly make the pot collapse. Some shapes, structurally sound when made in hard clay, will disintegrate as the water soaks in from the slip. Thin-walled pots are also very likely to collapse. It does take several minutes for the water to be absorbed and the clay body to soften. Usually what happens is that you carefully put your wonderful new pot on a board to dry, only to return half an hour later to find it a mass of soggy pieces tumbling over the edge. If you are putting slip on the inside of a thrown bowl you could guard against this by slipping the inside before turning the outside. Another way is just to make everything very thick.

Sometimes there is no way round the problem and you have to slip something that could well collapse – handles on mugs or teapots for example. In that case forced drying could be the solution. Place the pot in front of a fan heater until the slip surface hardens, or use a blow torch with a gentle heat on the areas most at risk.

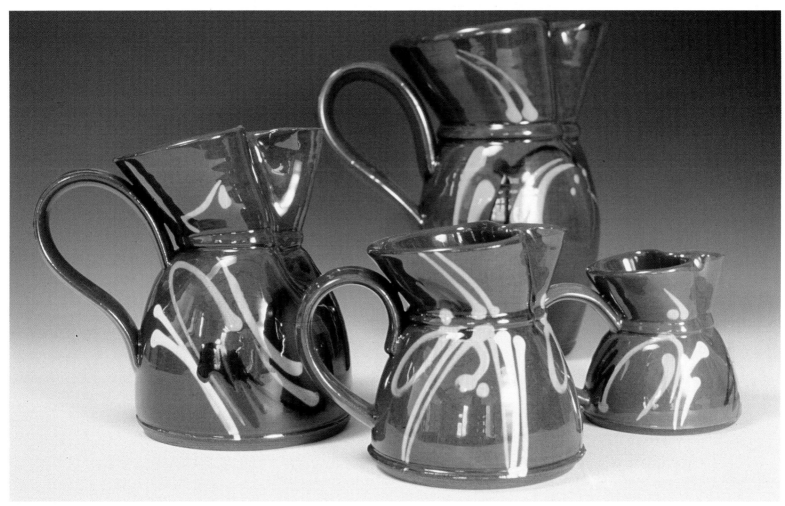

Jugs by Anthony Phillips.

DIPPING

Once slip is on a pot there is not much time before the slip starts to soften the walls of the pot, making it difficult to hold, so it is best to think out all the stages before you start: how to hold the pot when lowering it into the slip; how to lift it out; where to put it down, and whether you need a sponge handy to wipe off excess slip.

When you are ready to start, give the slip a good stir because it does settle and you could otherwise end up with the top part of the pot covered too thinly – something that may reveal itself only after firing it. Hold the pot in an area that is not to be covered, perhaps at one end or on the inside. Lower the pot into the slip as far as you need to go and then lift it out. There is no advantage in leaving it in the slip for any length of time. Shake the pot gently to remove excess slip, wipe off any slip on the base, and put it on a board to dry.

If there are areas that you do not want to cover with slip it may nevertheless be easier to dip the whole thing and wipe off with a sponge where the slip is not wanted. Alternatively you could wax the area before dipping (see pp. 47–8 on wax resist for more detail). With care it is possible to dip a small pot like a mug upside down with thumb on base and forefinger on rim without immersing the base. Some slip will go onto the inside but this can quickly be wiped off afterwards with a sponge.

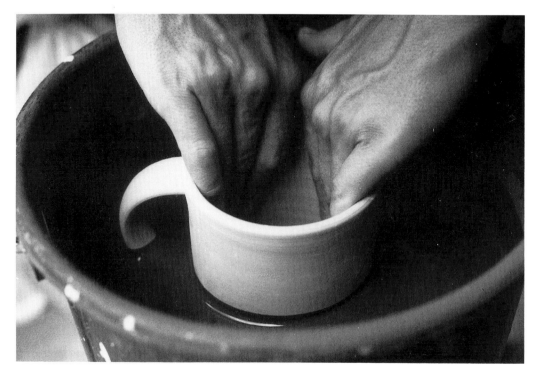

Dipping. *Covering the outside of a mug with slip. The mug is held by two hands inside and pushed into the slip.*

POURING

As with dipping it is always wise to plan out the process in your mind first and gather together everything you need beforehand. Stir the slip thoroughly, then take the pot in one hand and the jug or other container in the other and pour away. It is not always easy to work out how to hold the pot so that the slip does not splash all over your shoes. A large pot could be put onto two sticks placed across the top of the slip bucket; A smaller pot can be held with fingers by the base or the inside. When you have finished, wipe off any surplus slip and put your pot on a board. As with dipping, it may well be easier not to bother about slip covering unwanted

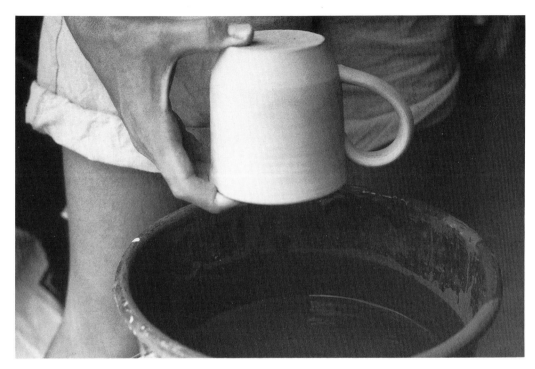

slip is a different medium to paint – the brush marks are different and the use of glazes can significantly alter the image – so even if you are skilled at painting it is necessary to experiment with different brushes, thicknesses of slip, and colours.

Gather together as wide a range of brushes as possible, in all sizes, of different materials and stiffness, and try out some coloured slips, seeing what marks can be made; use thin slips and thick slips, and try overlaying colours when the surface is wet and when it is dry.

One way of using brushes is to make a feature of the actual brush marks in the same way that Chinese painters or the makers of the decorated pottery of the 1930s did, where a brush mark can represent a bamboo leaf or

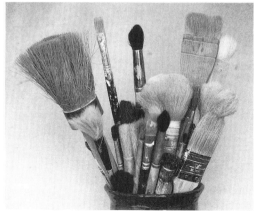

Dipping. *If you do not want the base covered in slip, the pot can be dipped upside-down. Hold the mug as shown and push it down into the slip. Some slip will go up the inside, but can be quickly wiped away.*

areas whilst you are pouring but to sponge it off afterwards or use wax or paper resist. Any missed areas can be touched up with a brush laden with slip straight away, but if

you are concerned about the mark showing it is often better to wait until the slip has dried back to the leather-hard stage before painting more slip on.

BRUSHWORK

Using brushes with slip gives all the scope and pleasure that painting can give, and all the same skills are appropriate. Nevertheless,

Paint brushes. *Any brush can be used with slip and each has its own 'signature'.*

a crocus petal. You can think of the surface of the pot as a canvas and work on the surface as a painter would, using brush marks to build up an image.

It may be helpful to sketch out your idea on the pot with a brush and a water-based ink beforehand (the ink will disappear in firing). Colours can be mixed together quite effectively, but it is much easier to keep aware of what colours you are using if you stick to the commercial body stains which are all coloured to be approximately the same as they will be after firing.

Slip can be brushed on in large areas, but if you are applying large quantities in one go then take the same care as with dipping so that the pot does not collapse, and allow time for the pot to dry and harden a little before adding more slip.

SPRAYING

Slips can be sprayed on provided you have a spray gun designed for fine-particled materials like clay and glaze (all the major pottery suppliers sell these) and a spray booth to extract the spray outside (breathing clay dust is potentially hazardous. Sieve the slip through a 120's (or finer) mesh sieve and do not make it too thick – single cream thickness at the most. Be sure to wear a mask when you are spraying. If a thick layer of slip is wanted it will probably be necessary to spray the slip on in several

Detail of bowl by Anthony Phillips.

layers, allowing the previous layer to dry first.

Spraying is a good way of putting slip (or glaze) on a pot that is too big, awkward, or delicate to hold for dipping or pouring. Putting on several thin layers minimizes the danger of collapse after slipping.

Spraying also offers several decorative possibilities of its own. Subtle shading and gradation of colours can easily be achieved. There is much scope for the use of stencils, too. Attach paper stencils to the pot in the same manner as for paper resist (see p. 45) and then spray over them. Leave the paper on until the slip has hardened, then pull it off and repeat with the paper resist on a different area, if you want. Alternatively, you could cut shapes out of thin card and hold

them in front of the pot as you spray. If you are doing a lot of spraying the card may go soggy and wilt, so try to find some more waterproof substitute for card – aluminium plates from offset-litho printing are ideal.

SPONGING

Sponges can be a very quick and exciting way of making a pattern by printing a simple design or creating a surface texture. It is easy to build up a pattern in several colours by using several sponges cut into different shapes. It is worth experimenting with both fine- and coarse-textured sponges – natural or synthetic – to see what effects they have. Use a sharp knife or pair of scissors to cut the design for printing, then soak up some slip into the sponge and dab it on. Being soft and flexible it will easily adapt to the curves and angles of your pot. You can build up several layers of colour by sponging on lightly so that some of the colours beneath show through; this will give quite an illusion of depth.

The advantage of this primitive process of printing is that it makes it possible to repeat the design easily on several pots or to build up a design on one pot by repeating simple elements.

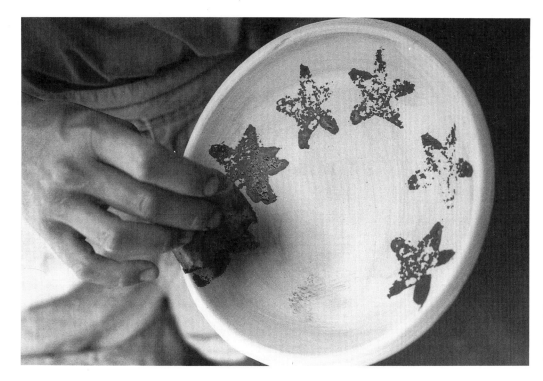

Printing with a sponge. *The sponge has been cut into a star shape. With slip soaked up into it, the star design can be printed onto any flat or curved surface.*

6 SLIP-TRAILING

Slip-trailing is one of the classic ways of using slip. The technique appears simple – the slip is held in a small container and squeezed through a nozzle so that lines and marks can be made on a clay surface – but does require practice to gain the necessary control.

Slip-trailing can be likened to drawing with a large felt-tip pen – lovely bold lines, but not suited to fine detailing or shading – and is excellent for the broad outlines of a design. A trailed line has very distinct characteristics: it always starts off with a blob at the beginning, then thins out along the length of the line until it usually finishes with another blob; this gives rounded, thick, comfortable lines, treacly yet precise.

Perhaps because the technique is limited to drawing lines that clearly stand out (physically as well as visually) from the background, it matters greatly not just what is drawn but how it is done. There is little scope for fudging, and part of the attraction of good slip-trailing is to see how the skill and deftness of the potter has been displayed in executing the design.

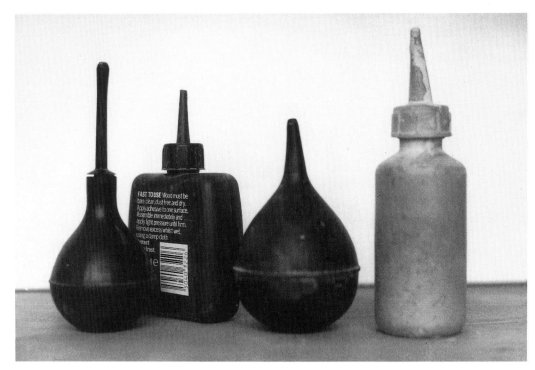

Some slip-trailers – designed for the purpose and improvised.

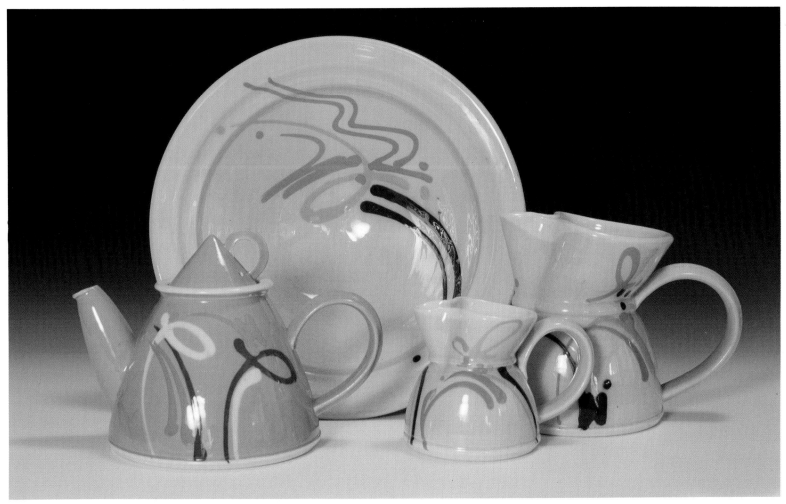

Large bowl, teapot and two jugs by Anthony Phillips.

THE TOOLS

Slip-trailers come in a variety of forms. The traditional trailer would have been a clay or horn container with a hole to fill at the top and a nozzle at one end with a quill stuck into it. The slip had to be fluid enough to run through the quill without blocking it up, and the flow was controlled by tipping the trailer up or down. It is conceivable that the potters could have used a leather bag like an icing bag, but there is no evidence for this.

In modern times, with the advent of rubber and plastics, slip-trailers are much easier to use. Pottery suppliers sell rubber syringes in two or three sizes which are ideal. Some have a removable spout to make them easier to fill up. They are small enough to fit into one hand, so you can move freely over the whole surface of the pot and the flow of slip can be easily controlled by pressure. Any similar kind of container could equally well be used, from small washing-up liquid bottles to any kind of dispenser that has a nozzle at one end – check your bathroom cabinet or chemist shop.

THE METHOD

Controlling the thickness of line is often a problem, and the difficulty is usually to get a line that is thin enough. One simple way is to insert a piece of the plastic casing that insulates electric cable into the nozzle of the slip-trailer. A 1.3–2 cm ($\frac{1}{2}$–$\frac{3}{4}$ in) length pushed

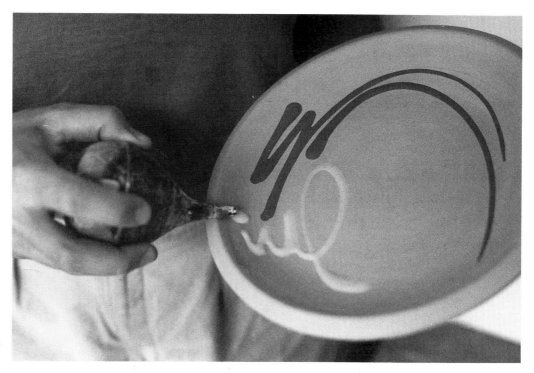

Slip-trailing in a bowl.

half-way in is sufficient, but it may take a little searching to find the right diameter cable to fit the nozzle and to make the line you want.

Always start off decorating with your slip-trailers full. One major cause of splashing and spluttering is when the trailer gets too empty and is not held vertically enough so that air is squeezed out with the slip, making unwanted splashes all over the surface. Another cause is lumpy slip – a lump gets caught in the nozzle, nothing comes out so you squeeze a little harder, and suddenly it all spurts out with a rush. Make sure the slip is sieved before you start, especially if it has been standing for a long time.

Plan out your design before starting; prepare some sketches and practise trailing the design on a table top or an unwanted pot before trying it on the real thing. There is little room for error in slip-trailing because it is difficult to wipe off even a small mistake, especially if you are trailing over another slip.

If you do make a mistake, try to incorporate it into the design in some way (you always have to be flexible with slip-trailing); but if it is too bad you may have to wipe everything off and start again. One good thing about slip-trailing is that it is obviously a technique that is hand-done and so imperfections and the odd mistake, far from being blemishes, can enhance that 'hand-made for you' aspect of the pot.

The quality of the line produced by the slip-trailer is determined by your skill in controlling the trailer. If you are nervous or hesitant this will be very evident in the lines you produce – they will be wobbly and awkward-looking and will detract from the overall impression – and so it is very important to practise this skill. Fill up your slip-trailer with a plain slip, and practise on a table top or on newspaper doing long straight lines, parallel lines, curves and swirls, thick and thin lines. Generally the most effective lines are those that are drawn quickly – the vigour and sense of purpose become evident, and the viewer can see how they were done and what went into their creation.

Very often slip-trailing is done onto a previously-slipped surface which can be either wet or dry, and each will give a different effect. If the background has only recently been slipped and is still wet, then the trailed design will sink into the background slip. Ideally the trailing will float in the background slip so that it is just slightly raised. Hold the slip-trailer so that the nozzle is just above the surface, and with gentle continuous pressure trail your design. Do not squeeze too hard or the line will be pushed by the force of the jet underneath the

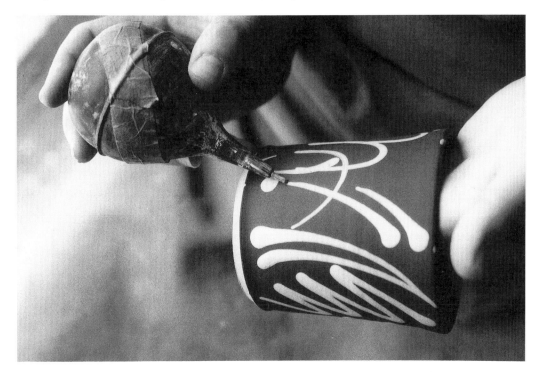

Slip-trailing on an outside surface. *The pot is held by the left hand inside so that it can be rotated easily. The slip trailer has a small piece of hollow electric cable insulation inserted in the tip to make it easier to trail fine lines.*

background slip and will disappear. This will be less of a problem if the trailing slip is thinner than the background slip. It is better to work slowly and methodically if trailing in this way, for if you make a mistake there is no way of erasing it without cleaning everything off and starting again.

The trailed lines tend to spread out a little in the wet slip, and so tend to be quite thick even when you are using a fine nozzle. The beginning and end of every line is marked with a well-rounded blob giving a soft, unctuous feel to the design – no sharp corners or rigid geometric shapes.

Alternatively, the background can be left until dry to the touch before you begin slip-trailing. The trailed lines will stand above the surface noticeably and will not spread out, so that the effect is different, with sharper and clearer lines. One advantage of trailing at this stage is that the trailed slip dries quite quickly, so that the pot can be moved around without such fear of dribbles forming. This is especially useful when decorating vertical surfaces for you can hold the pot in one hand, tilting and rotating it whilst trailing with the other. The slip-trailer can actually be held gently touching the surface of the pot, which should be hard enough to resist any significant marking, and moved about slowly or quickly as you wish. If you use a fine nozzle, thin lines are quite possible, though the characteristic blob at the beginning and end of each line will always be there.

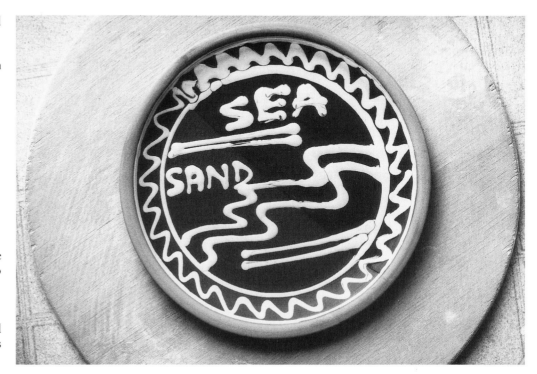

Slip-trailing on a dry and on a wet slip background. *The background slip on the upper right half was wet and on the lower left was dry.*

Take care that the background slip is not too dry, or the trailing is liable to flake off whilst drying or during firing. In the first stage of drying the slip goes from shiny wet to matt and dry to the touch. It is then in an ideal state for decorating. In the second stage it dries further and suddenly seems to go much lighter in colour, and it is then too dry to take slip. Carefully wetting down by spraying can bring it back to a sufficiently wet state, so long as it has not already dried out too much.

7 RESIST AND STENCILLING

This marvellous and simple way of creating a design that can become very sophisticated is based on the principle of masking out some areas of a pot and then applying slip to the surrounding areas. Several layers can be built up to create a complex design of shapes and colours. The two principal materials used for resist are paper and wax, and each produces a different effect.

PAPER RESIST

Paper resist is normally done when the pot is at the leather-hard stage so that it can take slip without collapsing. The paper can be used to mask out a design so that the slip covers the rest of the pot, creating a reverse image, or it can be done the other way around, cutting holes out of the paper so that only those spaces are covered in slip. The best paper to use is one that is absorbent but strong when wet – newspaper is ideal.

Cut or tear out from newspaper the pieces that are to be used as the mask. Wet them in a bowl of water and then place them onto your pot. They will stick on for a few

Paper resist – laying down the design. *Newspaper is an ideal material for paper resist. When wet it sticks to leatherhard clay and can bend to curved surfaces.*

minutes until they dry out, but it will be long enough for the next stage, which is applying the slip. This can be done by painting, sponging, dipping, pouring, or spraying, depending on the effect you want, and it is worth experimenting with all of them to see how they look. When the slip has been applied, let it dry back to leather-hard stage before removing the paper mask; carefully catch hold of one edge with a sharp point like a needle, and pull away.

The process can be repeated as many times as you wish, masking out different areas each time and using different coloured slips. Slip is usually used quite thick so that it is opaque and completely masks out what is underneath, but you could try using the slip thin so that the layers are only semi-opaque and the colours underneath show through a little. It will give more variation in tone and colour and give depth to the image.

Resist images are usually very stark – an area is either covered with slip or not, and the boundary is a clear line. The crisp lines make very strong shapes and demand a design that is bold and unequivocal: don't be half-hearted with the technique.

Sometimes it is more pleasing to have softer edges and a more gentle transition from one colour to the next, but you do not have to abandon resist if that is so. If the paper is not stuck down evenly onto the clay surface then slip can creep under the edges and blur the line. Glazes can soften the image, especially semi-opaque glazes and can sometimes make the colour in the slips run a little.

Paper resist – lifting off part of the design. *Slip has been poured into the bowl and then allowed to dry. The pieces of newspaper that form the paper resist design can easily be seen and picked off.*

WAX RESIST

Wax, or indeed any other water-repelling substance, can be used to resist slip. In practice there are just a few substances which potters use, though there is no reason for you not to experiment with others. With the wax you mask out the areas not to be covered in slip, building up layers just as with paper resist. By using a brush to put on the wax, the actual brush marks can be made a part of the decoration, adding a sense of spontaneity to the design.

Of all the waxes available ordinary candle wax (paraffin wax) is the best and cheapest. The wax is put on the pot before each layer of slip and left on. It will burn off completely during biscuit-firing ready for glazing. It needs to be heated to melting point, but it is dangerous to melt it over a flame or hot ring since it can easily overheat and catch alight. Paraffin wax melts at around 60°C (140°F), so a double boiler system, with the wax in a container sitting in a heated water bath, is ideal – a small saucepan inside a large saucepan containing 2.5–5 cm (1–2 in) of water kept simmering at boiling point, for example.

The wax can be used undiluted, though it may be too thick and cool too quickly for your needs. It can be diluted with a small amount of paraffin or light oil, which thin the wax and lower the melting point so that the wax will stay flowing longer from the brush. The paraffin does evaporate slowly

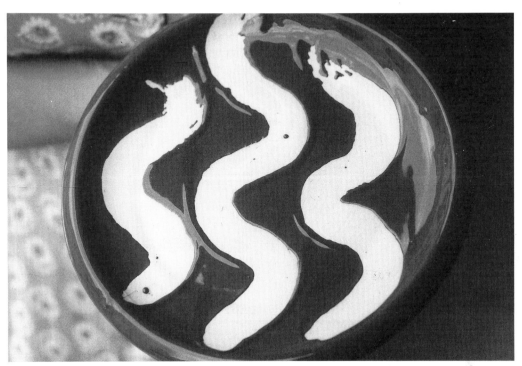

Wax-resist – wet slip surrounds the painted wax design. *Three broad lines have been painted with hot wax. The wax cools in seconds and slip can then be poured over. The wax repels the slip.*

from the wax, making it more smelly, and it will have to be topped up occasionally.

Wax is very effective in repelling the slip, which usually slides off immediately, though

if it is on the thick side, little droplets that have been left behind can quickly be cleaned off with a sponge. It is excellent for covering those areas like the base of pots which must not be covered in slip when dipping. The base can be dipped into the wax up to the required level if you have a suitable wax container (a frying pan perhaps?).

Once on a pot, wax is difficult to remove, so care must always be taken not to make a

mistake by getting wax onto the wrong part of the pot. On leather-hard clay it sticks well and cannot easily be scraped off without also taking away some of the clay underneath, necessitating a fiddly repair job. On biscuit-fired ware it can be burnt off completely by firing to around 300°C (572°F).

How the wax is applied is very much up to the artist and what kind of finished effect is required. The scope is wide, but as well as the use of brushes you could consider using the kind of copper funnel that is used for wax in batik work. A similar kind of effect could be obtained on slab surfaces by decorating with wax and then rolling up and unrolling the slap before putting on slip. A technique that has been done in the past is to mix oxides or stains with the wax so that the resist pattern can be coloured – the wax burns away during firing leaving the stain.

OTHER RESIST MATERIALS

Copydex (latex adhesive) can be used in a similar way to paper resist. It is water-based but, once dry, forms a thin elastic and rubbery film that can easily be pulled off from a leather-hard clay surface. Paint it onto the pot and allow it to dry before putting on the slip. If it is very thick, Copydex can be thinned with water, but not too much or it will be very difficult to remove. Leave the slip to dry back to the leather-hard stage. It will cover the Copydex completely, but it should be possible to see where the resist has been applied and, with a needle or pointed blade, to dig through the slip and catch a bit of the rubbery Copydex film and carefully pull it away. The slip covering will come away, too, leaving the exact pattern of the resist underneath.

Wax-emulsion is a water-based emulsion sold by most pottery suppliers. It is made for use on biscuit-fired pots, where it works well in resisting glazes, and would be equally effective with biscuit slips. On leather-hard clay it dries slowly and will resist thin watery slips well but not thicker slips. Like hot wax, once on it is difficult to remove without firing.

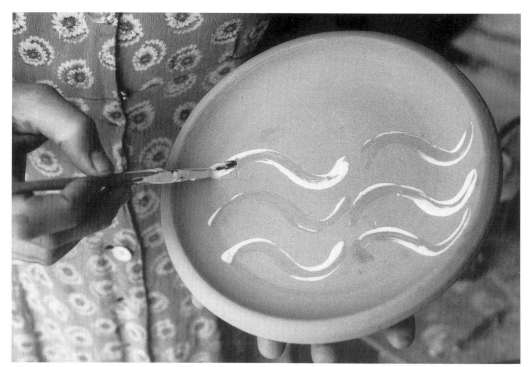

'Copydex' resist. *Painting the design. Slip can be poured over once the 'Copydex' has dried.*

STENCILS

In some ways this technique is similar to paper resist, but stencils can be used much more flexibly to print an image, either through or around the stencil. The main ways of printing are spraying, painting, and sponging the slip; and, as with resist, several different images and colours can be incorporated into one design, though each one will usually have to be done separately, with drying time in between.

The stencil can be made of any rigid material – thin card or cardboard works well, though can become soggy if overused. Just holding it against the surface of the pot may well be perfectly adequate, especially if you are decorating a flat surface, though if you are spraying it would make it easier to put the stencil on a stalk made of card, wire, or a wooden stick, so that you can hold it in front of your pot in any position or at any distance you wish. Leaves, stalks, flowers, lacy fabric and other objects are worth experimenting with.

As with any stencil technique the delineation of the image will not be exact – there is bound to be some blurring at the edges (unlike paper resist). But that is part of the effect which adds interest and variation to the design. Once the stencil is made it is quick to use and easy to build up a repeat pattern over a surface. It works well in conjunction with other decoration techniques such as brushwork, slip-trailing, and sgraffito.

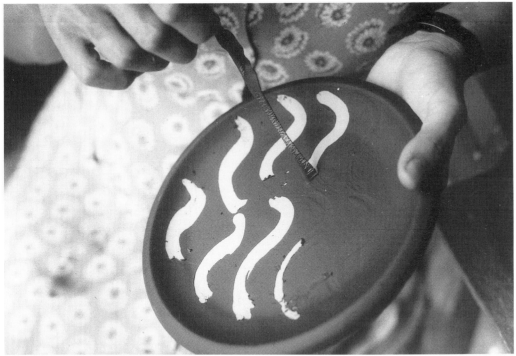

'Copydex' resist. *Lifting off part of the design, stretching the 'Copydex' like a rubber band.*

8 FURTHER DECORATING TECHNIQUES

SGRAFFITO

The name is Italian, though the technique is universal and as old as pottery-making itself. Sgraffito is the name for decoration that is scratched into the surface of a pot, and usually means scratching through a layer of slip to reveal a different colour underneath. Lines or whole areas can be scratched or carved out, and with the appropriate tool sgraffito is a quick and flexible form of decoration that is easy to learn.

TOOLS

Some pottery suppliers sell special tools which they call sgraffito tools, as if there were only one kind of tool that can be used. In fact you can use absolutely anything which is capable of making a mark in clay, from a needle to a stick, a comb to a stiff brush.

If you are going to do any amount of sgraffito it is essential to try out as many different tools as possible. Gather together anything you can find that could conceivably be suitable, and experiment to see what kind

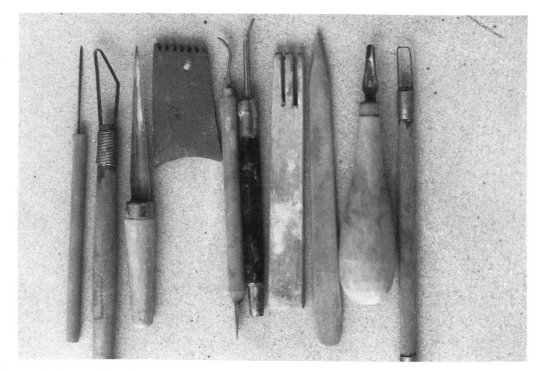

Tools for sgraffito. *A variety of tools which can be used for sgraffito.*

of marks they can make – pressing lightly, digging in hard, moving quickly and slowly. Try getting fine lines and thick bands; see if it is possible to get soft contrasts and shading. Tools with more than one tooth – a saw blade or a comb – can make very attractive patterns. Learn how to hold the tools comfortably so that you can make wavy lines as well as straight ones, and see which are more useful for doing fine work such as lettering.

Of course the proprietary sgraffito tools do have their uses and are well worth trying. Some tools are excellent for doing straight line work or banding on a wheel, such as a tool in the shape of a hook which you draw towards you, or the tip of a hole cutter held so that the hollow (concave) side is leading. They both have the advantage of carving out a channel without leaving large ridges of clay on either side. A blunt-ended tool is ideal for complicated work like lettering where the tool has to move in every direction without digging in and where a fluid movement is essential. Something like a blunt pencil or the end of a brush-handle would be suitable.

As the tool carves through slip and clay the debris is deposited on either side and soon builds up. Resist altogether any temptation to brush away the bits with your fingers, for you are bound to rub some into the surface and smudge your design in a way that cannot easily be repaired. Instead use a large soft brush and wait (if you can) until the pot has dried, or at the very least until the clay crumbs have dried. Brush them off gently, taking care not to raise too much dust into the air. Once the pot has dried, if there are still too many lumps and bumps stuck to the surface you can rub over them with a finger to dislodge and smooth them with no fear of smudging.

Sgraffito is best done when the clay is between leather-hard and nearly dry. When too wet, the clay displaced by the tool sticks to the slip on either side of the line and is difficult or impossible to remove without making more of a mess. When too dry, the slip at the edges of the scratched lines tends to break rather raggedly, and it is much harder to scratch through. Sgraffito need not

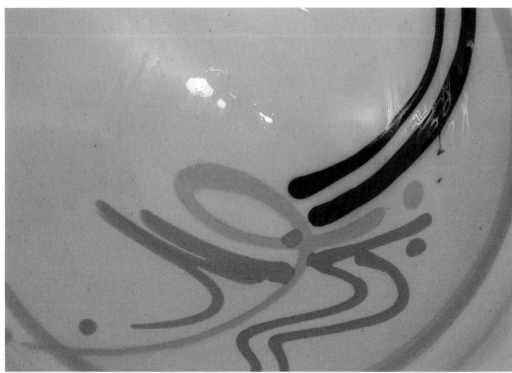

Detail of large bowl by Anthony Phillips.

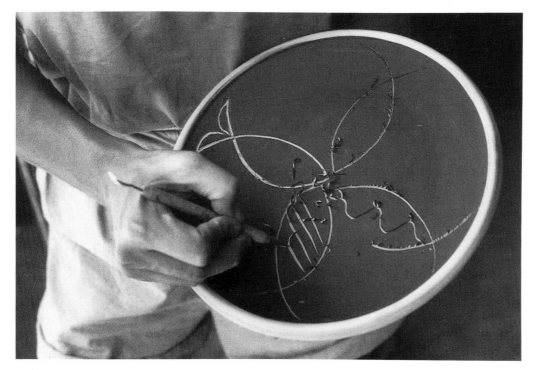

Sgraffito onto a plate. *The debris should be left to dry before you brush it off to avoid smudging.*

be just linear: a knife or wire tool can be used to scrape away slip to reveal larger areas of the clay underneath.

Sgraffito is lovely combined with other techniques. Very different effects can be achieved by varying the way in which the

slip is put onto the clay surface to begin with; brushing, sponging, dipping, or pouring all look very different. Slip, underglaze colours, or oxides can be painted or slip-trailed on after sgraffito, perhaps to fill in between the lines or to highlight them.

If doing a complicated design in sgraffito it may be worth while mapping out the design on the pot. You can do this when the pot is hard enough so that a soft pencil will not dig

in. The pencil marks will burn off during firing. For greater sophistication you could put several layers of different coloured slips onto the pot surface before sgraffito. Then, with care, it is possible to scratch through one or more layers, revealing different colours underneath.

FEATHERING

This technique produces beautiful delicate patterns that to the uninitiated are quite inexplicable. Yet, though it needs care and a steady hand, it is not difficult to do. The result is spectacular and so striking that it is usually seen on its own, rather than with other techniques.

Feathering can be done only with slip. There was a vogue for it in the seventeenth and eighteenth centuries as a way of decorating very simple press-moulded dishes, and the classic colour combination was white on black with a clear lead glaze covering. Since then it has been much neglected by serious potters and exists now in the curriculum of the student potter as a curiosity rather than a process to be explored and developed.

The method is simple – to draw a fine bristle, wire, or needle across stripes of contrasting coloured slips. The viscosity of the slip ensures that as the 'feather' moves across the stripes it drags a little bit of slip of one stripe through the next.

The easiest way to do feathering is on a

flat surface. Roll out a slab of clay onto a board and pour some slip onto the slab. Tilt and roll the board until the slip covers the whole surface, then pour off any surplus. Fill a slip-trailer with a different colour slip of the same consistency and trail this across the slab in stripes, leaving an equal space between the stripes. At this point the trailed lines will stand up a little above the level of the first slip and you can gently tap the board on the table-top so that they sink in.

For the 'feather' take a stiff brush hair or a strand of fine wire, lay the tip at one end of the slab and draw it steadily across the stripes to the other side to make the feathering pattern. Now repeat at intervals across the slab.

That is the essence of feathering, but you can extend the technique in many ways. Change direction and draw the 'feather' in the opposite way across the slab, so that the 'tears' go in both directions. Try going diagonally across the surface, or work on small sections of the slab to make a patchwork of different designs. Use other things as your 'feather', such as very fine hairs or thicker wire, a needle or a wide-spaced comb, so that you can make several lines at a time. There is no rule about making only straight lines, so see what happens if you make curved or wavy lines. . .

Now that you have exhausted the possibilities of working on a format of stripes think about feathering on other formats such as polka-dots, zig-zags, or other patterns not necessarily geometric. See what

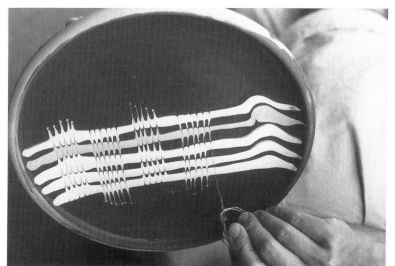

Feathering. *On a dark slip background lines of white slip have been trailed. Whilst the slips are still wet, a fine wire is dragged across the lines to create the feathering.*

Appliqué – tearing away the paper backing. *After laying the piece of appliqué onto the clay surface and pressing it on as hard as possible, the paper backing can be peeled off.*

happens if you use more than two colours.

So far all the discussion has been about decorating on a flat surface. Once the slip has been allowed to dry you can use the slab for a press-mould or for slab-building. If you are afraid of marking the beautiful feathering with dirty fingers whilst handling it, you could cover it with a sheet of cling-film or very thin polythene. It is, in fact, just as easy to feather onto a slab that is already in a mould, but be sure not to take it out of the mould until the slip has dried or it will collapse. You could work on the inside or outside of a thrown or hand-built bowl in a similar way, perhaps using a slip-trailer to trail the initial pattern by making circles around the bowl as it turns on the wheel.

APPLIQUÉ

In ceramics there is always room for experimentation. The limits of slip decoration can never be defined, and no book can ever be expected to cover every single process. Appliqué is an example of another way of using slip and shows that you do not have to limit yourself to only the traditional slip-decoration methods. I devised it as an alternative to paper resist because I wanted to work directly on creating images with different colours.

Appliqué uses a thin sheet of leather-hard slip from which pieces are cut, torn, or stamped out and then pressed onto a clay surface. The design stands in slight relief, much like slip-trailed decoration. It is possible to build up an entire design in this way using as many colours as desired, or it can be used as part of a decoration incorporating other techniques.

To make the thin sheets you need a flat plaster slab and some sheets of strong but absorbent newspaper, about A4 size. Wet the plaster surface a little and soak the newspaper in water. Next smooth the wet newspaper onto the plaster slab. Wait until the paper is no longer sopping wet, but remains damp, and then pour slip onto it and tilt the slab until the paper is covered. Pour off any surplus and leave until the slip has dried to leather-hard. The thin sheet of slip with its paper backing can be lifted off easily and wrapped in polythene until needed. Its thickness is largely a matter for your choice, for it can be anything from 0.5 mm ($\frac{3}{128}$ in) upwards.

The sheets should be dry enough to handle without marking but damp enough so that they do not split and crack when bent and twisted. If necessary you can damp them down by lightly spraying with water. Cut, tear or stamp out the pieces that make up your design but do not remove the newspaper backing at this stage. Sticking them to a clay surface can sometimes be a little fiddly. To avoid cracking during drying and firing, it is better to have the clay of the pot wetter than the appliqué pieces. Water is sufficient to stick them on; spray the surface of the pot with water and then press the pieces firmly on with newspaper side up while the surface is still wet. If you are putting them on a previously slipped surface it can be done whilst the slip is still a little tacky.

The newspaper can be left on and burnt off during firing, but if you want to work further on the decoration use a needle or point of a knife to prise up one edge and pull it off (it is at this point that the quality of the newsprint reveals itself).

The attraction of appliqué is its flexibility and the fact that once the materials have been prepared a whole design can be created in one go. You can build up a design step by step and test how each piece will look on the pot before sticking it on. It is quite easy to overlay one piece over another, and to add greater interest, you could pattern the sheets of slip before cutting them up, for example, by slip-trailing, painting, marbling, feathering or paper-resist.

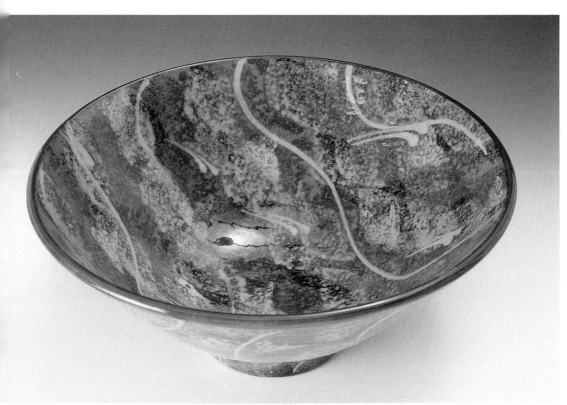

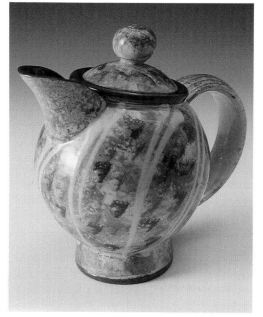

Bowl by Anthony Phillips. *Sponged decoration with slip-trailing over.*

Teapot by Anthony Phillips. *Sponged decoration with slip-trailing over.*

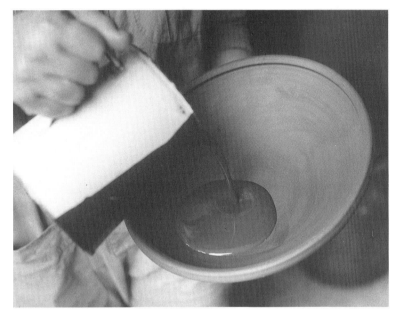

Marbling. *Pouring the first colour slip into a bowl.*

Marbling. *Swirling the slip around to cover the whole surface. When the process is finished, the surplus should be poured out.*

MARBLING

Another technique which produces a very striking pattern is marbling, which requires no tools at all but just some deft manipulation of pot and slips.

As with other slip decoration, marbling with slips was used on country pottery from the seventeenth century onwards, primarily as a decoration inside press-moulded dishes.

There are some examples of marbling used on industrially-made ceramics in the eighteenth century but it died out as printed decorative techniques were developed.

It is easiest to think of marbling as a technique for dishes, plates, or bowls because they have a good surface for the decoration – a flattish concave surface – and are easy to handle, but there is scope for ingenuity in marbling on vertical surfaces like jugs or vases. Marbling can also be done with coloured clays with similar results, although the technique is more time-consuming and less predictable.

To describe marbling with slips let us assume for now that the pot to be decorated is a dish and we shall be decorating the inside surface. It will have to hold its shape while a good quantity of slip dries out, so it is important to think carefully how that can

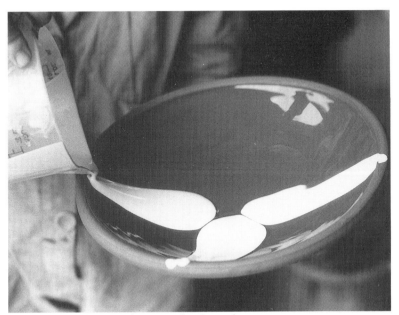

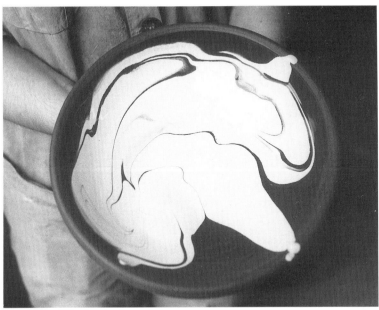

Marbling. *Pouring in the second colour slip. Only a small quantity is needed.*

Marbling. *The beginning of the process as the two slips are swirled together.*

be done. One of the easiest ways is to make a press-moulded dish and leave it in the dish-mould whilst marbling so that it is supported by the mould. A plaster mould will also help to dry it out more quickly. Otherwise try to ensure that the dish is strong and thick and will support its own weight even when the clay is soft.

You will need at least two different coloured slips of the same consistency, not too thick. While you are getting used to the technique, use just two contrasting colours to try out the different effects that can be obtained. Pour enough of the first into the dish to swirl it around till it covers the whole of the surface, then pour off the surplus. There is no need to drain it thoroughly – just ensure that a good thick layer is left. The way the second slip is put on has an influence on the marbled appearance, and

with practice you will quickly learn how it works. To begin with pour or trail with a slip-trailer a simple pattern of thick stripes, spots, or wavy lines onto the first slip. There is no need to be neat or precise at this stage for the crucial part comes next.

Take the dish in both hands, holding it underneath or by the sides, and with sharp movements, side-to-side or circular, make the slips move around the inside of the dish. The

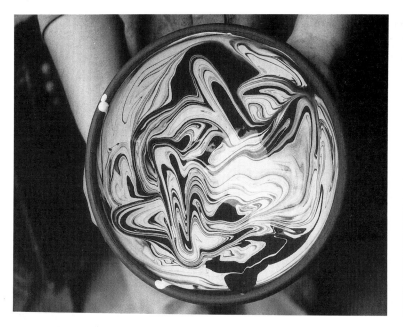

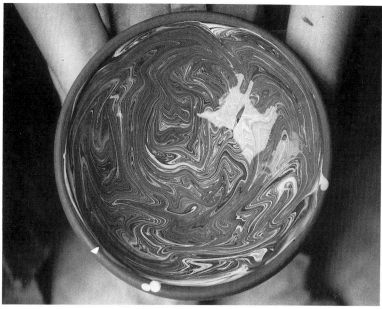

Marbling. *The pattern gets denser the more the two slips are mixed together.*

Marbling. *And denser still.*

slips will quickly form a marbled pattern, and the more you move them around the finer pattern will become and the more mixed the colours will be. When to stop becomes a purely aesthetic judgement for you – when does it look right? – but while you are experimenting with the technique and learning what it can do, try at least once to go the whole way and make a marbled pattern with the finest possible lines so that

the colours almost seem to merge. Try also hardly mixing the colours at all so that you have a very coarse pattern.

Another way to start marbling is just to pour all the different colours of slip into the dish at the beginning, say half a cup of each. Then, as you move the dish to make the slip cover the whole surface, the marble pattern will be created at the same time. The effect will be quite random but just as pleasing.

Pour off any surplus slip at the end. Don't be afraid of slip pouring over the edges as you do the marbling – it just is not a tidy process and it should be easy to wipe off runs, dribbles, or splashes with a sponge afterwards.

It is possible to maintain quite good control of the process if you are careful. It all depends on how you set up the initial arrangement of slips before marbling and

then on creating the marbled effect with controlled movements. You could start off with a strongly-defined geometric pattern and then introduce an element of unpredictability and variation by careful marbling movements. Again, with some ingenuity it is possible to vary the degree of marbling from one side of a dish to the other.

The choice of colours can play a large part in the effect. The traditional colours are black and white but beautiful effects could be achieved by using several different tones of the same colour, perhaps with a small amount of another colour to provide a contrast. Marbling in very pale or pastel shades could be an ideal background to some other decoration.

INLAY

Sharp well-defined areas of colour in the surface of the pot are the hallmarks of inlay decoration. From the finest lines to broad areas of colour there is, by the nature of the process, always a definite border between the inlay and the clay body. It almost seems to require a decorative design that is neat and precise.

The word inlay implies that there is no relief on the surface of the pot: the decoration is set into the surface and neither stands out from nor sinks below the level of the clay. In practice there is no need to stick to any such rule, and some relief in the

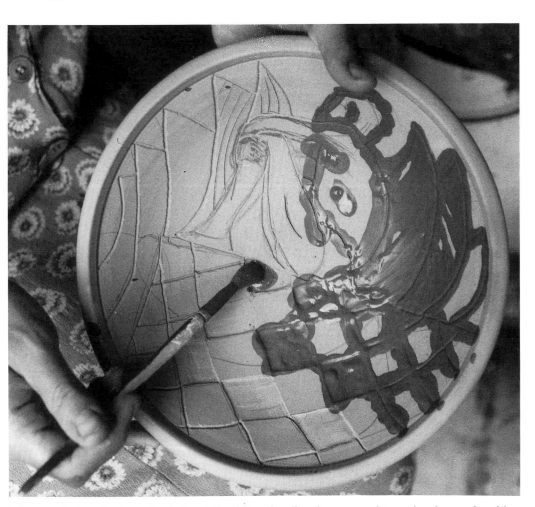

Inlay – painting slip into the design. *The design has first been carved into the clay surface like sgraffito. At least two layers of slip will be needed to fill the design.*

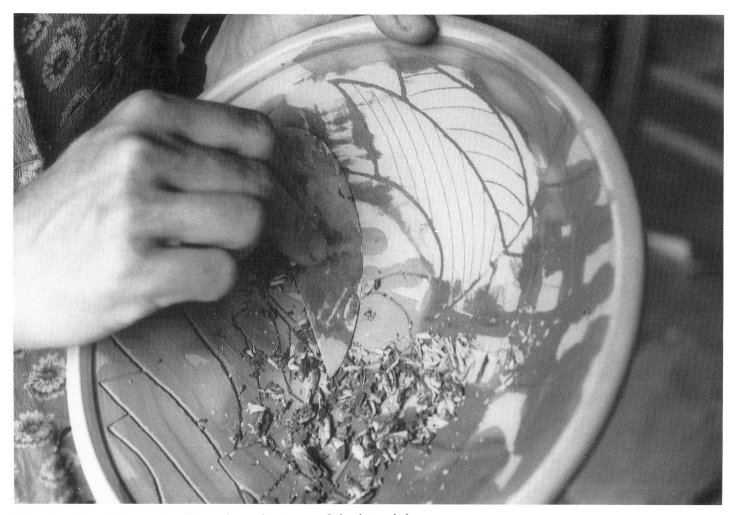

Inlay. *Scraping off the surplus slip on the surface to reveal the design below.*

design could add to the qualities of the decoration.

The design must first be carved out or impressed into the surface of the pot. It is not necessary or desirable to go deep, but not less than 2 mm ($\frac{3}{32}$ in) is a rough guide. A sgraffito tool or a wire-loop tool can be used to carve away the clay. A stamp made out of plaster, fired clay, wood, metal, or plastic could be used to press into the surface. If the design is carved out, the clay body should be at the leather-hard stage so that it is easy to clean away any bits of debris at the edges of the design. If stamps are used, the clay needs to be softer to prevent distortion and cracking in the surrounding clay.

The inlay material is usually slip which is painted thickly into the carved areas. Enough slip should be put on so that it stands just above the level of the surrounding clay once it has dried. This may require more than one application of slip. Alternatively, soft clay can be pressed into the grooves. The inlay clay or slip should overlap the edges to ensure the join is well made. It may look quite a mess at this stage.

The slip or clay must be allowed to dry before the surplus is scraped away. This is best done when the pot is nearly but not yet dry. If it is too dry, the scraping will scratch the surface and raise a great deal of unhealthy dust; if too wet, the colours will smudge. The scraping can be done with a metal kidney or knife blade. Work carefully and slowly and, as you take away the surplus inlay, you will see the design appearing like magic underneath.

Once all the surplus has been removed, the surface can be finished off by burnishing or sanding, if a smooth surface is wanted, or it can be glazed. Cracking of the inlay material can occur if it has a much higher degree of shrinkage than the clay body. This can happen if the compositions of the two clays are very different or if the inlay is coloured with an oxide like copper or cobalt which fluxes easily (body stains are neutral fluxes and will not have this effect). Ideally it is best if the clay body shrinks just a little more than the inlay so that it will squeeze onto the inlay as it shrinks and hold it tight. As an example, red earthenware shrinks much more than white earthenware, so red inlaid into white will create shrinkage cracks in the red clay but white inlaid into red will not.

9 FINISHING

BURNISHING

The sheen of a burnished pot is one of the beauties of ceramics. The surface is polished smooth and shiny yet is not reflective; it invites touch yet is delicate. It is a technique which easily pre-dates glazes, and in some regions – particularly South and Central America – was so effective that glazes were almost never used.

Burnishing requires long and painstaking work, for every part of the surface has to be polished, often more than once. Burnishing tools vary considerably. What is required is a smooth rounded surface, like a pebble or the back of a spoon, which cannot dig into the surface and gouge out lumps of clay as it is used. To burnish you must press your spoon

Burnishing – burnishing slip with the back of a spoon. *The burnished area darkens considerably and a good sheen can be developed which can be enhanced by polishing with smooth polythene, wrapped taut around a finger.*

or pebble firmly to the surface and, with small rotary or linear movements, polish the surface. The action of burnishing seals the surface, and the colour darkens as the shine improves. Work on a small patch at a time. Where the pot has angles and crevices you will have to devise your own tools to get at those awkward places.

The clay body should be drier than the leather-hard stage so that the tool does not make too big an indentation in the surface. A better polish is achieved, too, if the clay is fairly dry. You may find it even better if you burnish twice or go over a second time with a soft cloth or polythene stretched over a finger. If the pot is too dry, however, it will be impossible to get a good shine, and once a pot dries the very high shine will seem to fade. It will be difficult to get a good shine from a coarse clay. The best burnished surface comes from a very small-particled clay such as a terrasigillata. Whilst it is probably impractical to use such a clay to build with, it can be used as a slip over a coarse clay and then burnished. (See p. 28 for details of how to make a terra sigillata slip.)

Vase by Sara Robertson, *Handbuilt by coiling and pinching in red earthenware clay. The slip decoration is predominantly painted with some sgraffito and inlay as well. The surface is burnished to give a smooth finish. Fired to 1100°C (2012°F).*

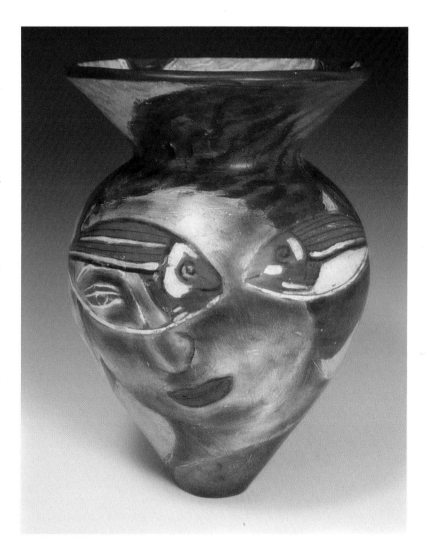

A burnished pot must never be fired high if the shine is to be retained. Above about 950°C (1742°F) the burnish will almost completely disappear, as the clay begins to alter its structure. The lower the temperature the better to keep the original shine, but that can bring other problems because the clay will be soft and fragile. A compromise would be to fire to between 850–950°C (1562–1742°F).

After firing some of the shine will have returned. To improve it further the pot can be polished with some kind of wax polish. Beeswax polish is very good, but shoe or furniture polish can also be used.

SANDING

A smooth matt unglazed surface can be produced by sanding the surface with very fine sandpaper and wet-and-dry paper. It is possible to get a very smooth finish that can feel every bit as good as a glazed or burnished surface. It is an alternative to glazing for pottery which needs to be fired higher than the limit for burnishing – porcelain for example.

The pot can be sanded lightly when it is dry and unfired. It will be very fragile at this stage so great care must be taken when handling it. The clay is very soft so a very fine sandpaper is needed to avoid scratching the surface. This does create a great deal of dust, which is dangerous if inhaled, so always wear a mask if sanding dry clay. A

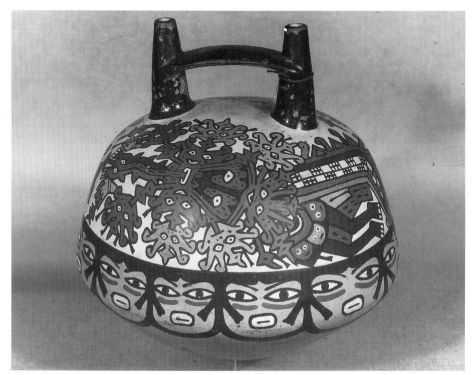

Globular vessel, *Nazca, Peru. Painted in several different colours of slip: black, red, tan brown, yellow. Burnished and unglazed. (British Museum).*

better alternative is to fire the pot to a low biscuit before sanding. It is then strong enough to be handled easily and the sanding can be done with water so that no dust is created. Use wet-and-dry paper, starting with a medium-fine grade and then progressing to finer grades until you finish with the very finest that almost polishes the surface. Keep the surface very wet to lubricate the wet-and-dry and prevent scratching. The pot can then be fired again to the desired temperature and the surface worked on again with the finest wet-and-dry to get the best possible surface. It can be polished with beeswax to give it more of a shine.

10 GLAZES

Glaze is a kind of glass that has been specially formulated to fit onto a clay surface. Glass is mainly silica (sand, flint, or quartz) with some added fluxes such as sodium, lead, or borax to make it melt at a reasonable temperature. A glaze contains similar ingredients but it also has to fulfil specific requirements to make it suitable. It must be able to stick onto the surface of a pot, so it must have a similar rate of expansion and contraction with heat, and it should melt at roughly the same temperature as the clay matures. Both of these can be achieved by adding alumina, which is also a main constituent of clay, and in practice the easiest way of adding alumina is to add clay to the glaze.

An earthenware glaze is one that fires up to about 1200°C (2192°F) but more usually in the range 1040–1120°C (1904–2048°F), whilst a stoneware glaze is generally considered to be one that fires above 1200°C (2192°F) to about 1300°C (2372°F) (commonly 1260–1280°C (2300–2336°F)). There is no strict definition of the two types of glaze. The composition of stoneware glazes is not far different from that of stoneware clays, so that the glaze tends to fuse into the clay body and there is no clear dividing line between them. An earthenware glaze, however, melts over the clay but does not fuse with it and remains as a very distinct layer on the surface of the clay. Earthenware tends to be porous and weaker than stoneware, which is usually vitrified and not porous. A greater range of pigments can be used at earthenware temperatures. Stoneware clays contain materials, notably iron, which affect the colour and texture of the glaze at stoneware temperatures. Because of the different temperatures, earthenware and stoneware glazes use largely different fluxes and these can have a determining effect on the nature of the glaze.

Potters using slip decoration very often use a transparent glaze which provides a hard, smooth, protective surface and enhances the colours of the slip. It can be shiny or matt (matt glazes tend to be slightly opaque), clear or coloured. The emphasis of the decoration is on the slip rather than the glaze. Even under a semi-opaque or opaque glaze, slip can add a distinct quality to the overall decorative effect, especially if the less stable oxides such as copper, cobalt, manganese, or iron are used in the slip so that they bleed through into the glaze. In the decorative concept both glaze and slip are equally important and neither would be effective without the other.

The range of possible combinations of slips and glazes is enormous and would be impossible to catalogue and describe adequately, especially when other variables like thickness of slip and glaze, firing temperature, and kiln atmosphere are bound to play an important part. It is a case of experiment and discovery on your part until you establish something that works the way you want it to. In this discussion of glazes, most emphasis will be laid on transparent glazes, shiny and matt, which can of course be stained just like slips, though smaller concentrations of stain, roughly a half, will be needed.

EARTHENWARE GLAZES

Earthenware glazes are usually categorized by the kind of fluxes used in them because they have the greatest effect on the nature of the glaze and its colour response. The main fluxes used are lead, the alkalis sodium and potassium, and, to a small extent, zinc. Borax, although not strictly a flux (it has different chemical properties that make it more akin to alumina), has a low melting point which means that it can be used in a similar way to a flux.

LEAD

Lead has been used in glazes for over 4000 years and most earthenware pottery has, in the past, been glazed with lead. It has excellent properties for glazes, making them melt and smooth out at a low temperature; it gives very good rich colours and a fine glossy glaze surface. Lead and clay mixed together is sufficient to make a very workable glaze. Before the Industrial Revolution, raw lead in the form of easily-made lead compounds like litharge, red lead, white lead, or galena was often used on its own, dusted onto the pottery ware. It reacts with the silica and alumina in the clay body to form a glaze during firing. It was also mixed with clay and sometimes flint before being used to raw-glaze pottery. The Industrial Revolution brought the need for more reliable and better-quality glazes and, later on, safer glazes.

Unfortunately lead has one serious disadvantage – it is extremely poisonous. Potters who used raw lead in their glazes put themselves at high risk of lead poisoning and an early death. Even the pottery they produced was not safe: the lead in some glazes was quite soluble and could dissolve into food, particularly acid foods like wine, vinegar, or fruit. It was not until the early twentieth century that a safer way of using lead was discovered – the frit, in which lead is combined with silica. This is done by heating lead and silica to melting point then cooling and grinding the fused material to a powder which can be used in a water-based glaze with other powdered ingredients. This process dramatically reduces the solubility of lead both in the raw-glaze state and the fired glaze. There are two lead frits commonly available – lead sesquisilicate and lead bisilicate. Though both of these are relatively safe to use, lead bisilicate has lower solubility in the raw state and contributes to safer glazes.

There is no rule that can be used to determine whether a particular lead glaze recipe will yield a safe glaze since it also depends on what other ingredients are used, their proportions, and the firing temperature. There is a British Standard with which all pottery that comes into contact with food must comply, and it is possible to have samples tested at a very reasonable cost. Ready-mixed glazes available from pottery suppliers are normally quite safe provided they are used and fired according to the suppliers' guidelines.

Lead, in the form of lead bisilicate, is a good flux at 900–1150°C (1652–2102°F). Above that it begins to vaporize so it cannot be used in stoneware glazes. A very satisfactory shiny clear glaze can be made containing lead bisilicate, china clay and flint, with the possible inclusion of a feldspar and whiting. Lead glazes have a slight yellow tint to them and are soft and easily scratched. The addition of small amounts of sodium/potassium, calcium, barium, or borax will help to harden the glaze, though they may effect its colour response. Lead glazes have a very wide firing range so they can tolerate variations in temperature or slight modifications in composition.

BORAX

Borax, or more correctly boric oxide, can be used in combination with alumina and silica to make very satisfactory leadless glazes. Transparent glazes are clear and colourless; when used, they tend to be strong yet cool in tone. It can be used to produce glazes with melting points as low as 500°C (932°F).

Boric oxide is the compound used in glazes; borax is the mineral, found in vast quantities in the U.S. Boric oxide is soluble in water so is not ideal for use in water-based glazes. It is normally added to glazes as a frit combined with silica, alumina, and small amounts of calcium, potassium, sodium, and other elements. There is a

Box with lid by Robert Cooper, *Slip-decorated by an unusual process: a plaster cast of a relief fabric is taken and the cast is then painted with coloured slips. The whole surface is then covered with a layer of clay with the consistency of yoghurt. In drying, the slip unites with the clay and the whole slab can then be lifted off to be used to form the pot, cutting, distorting and adding clay where necessary. Stoneware fired. Some glaze, on-glaze enamels and lustre are also used.*

variety of borax frits available to the craft potter, formulated for different uses and different temperature ranges, from as low as 750°C (1382°F) up to 1180°C (2156°F). Though borax is not itself a flux in the strict sense, behaving chemically like alumina in glazes, it has a low melting point and so can be used in low-temperature glazes without the addition of a flux, if necessary.

Borax has properties which make it very useful as an addition to another glaze. It is very tolerant in firing and can extend the firing range of a glaze; it can help to smooth out a glaze during firing and avoid bubbles and pinholes, and, if used in small quantities (less than 15 per cent), will increase the craze resistance of the glaze.

CALCIUM BORATE FRIT

This is a frit which is made as a substitute for colemanite, a naturally-occurring mineral containing calcium and boric oxide. When used in large amounts it can produce very beautiful effects through its tendency to cause opalescence in the glaze. The frit is preferable to natural colemanite because glazes containing colemanite tend to flake off during firing. It can also be used in stoneware glazes.

Opalescent glaze recipe fired to 1100°C (2012°F):

	%
calcium borate frit	60
china clay	10
potash feldspar	30
copper oxide	5

LEAD BOROSILICATE GLAZES

The most widely used glazes in industry are from the range containing both lead and boric oxide, usually known as lead borosilicate or low-solubility glazes. They combine the advantage of both materials resulting in glazes which are glossy, tolerant of variations in firing temperature, give good and reliable colour response with stains and oxides and are less prone to glaze defects.

ALKALINE GLAZES

Some very beautiful colours can be obtained with the use of alkaline glazes and oxides – vibrant turquoise from copper, purple and mauves from manganese, red-browns from iron. Alkaline glazes contain sodium and/or potassium as the principal flux, together with alumina and silica. Because they have a very high expansion rate it is almost impossible to prevent them crazing, so this limits their use mainly to non-functional ceramics, where they can be especially effective if the crazing can be exploited as part of the decoration. They are widely used in raku because they can be used at low temperatures (less than 1000°C (1832°F)), and raku techniques can make very good use of the crazing. High-alkaline glazes are also soft and easily scratched. Middle-Eastern potters in the fourteenth to seventeenth centuries were able to use alkaline glazes without crazing by using a clay body made up of 80 per cent quartz, 10 per cent ground glass, and 10 per cent plastic clay covered in a slip made up of quartz and ground glass.

Natural forms of sodium and potassium that can be used at earthenware temperatures are all soluble in water, and although it is possible to use materials like soda dissolved in the glaze slop, it is easier, more reliable, and safer if the sodium is in frit form. Alkali frits contain sodium and sometimes potassium, alumina, silica, and boric oxide. They can be fired as low as 750°C (1382°F) and up to about 1100°C (2012°F). Sodium and potassium feldspars can be used at higher temperatures.

ZINC

Zinc oxide is not a good fluxing material and is rarely used on its own in a glaze at earthenware temperatures. In small amounts it can help the glaze melt more easily, but with larger amounts it tends to make glazes opaque and matt. It is often used in lead and boric glazes in small quantities because it reduces crazing and hardens the glaze surface. Even small additions of zinc will affect colours from oxides. It makes iron very dull and dingy, but enhances the colour effects of cobalt and copper.

STONEWARE GLAZES

Even though there is no clear dividing line between earthenware and stoneware glazes there are significant differences which make it reasonable to consider them separately. Stoneware glazes are composed of largely

different materials, there are some colour effects which are only possible at stoneware temperatures or in reduction, and it is generally possible to get a wider range of surface texture and quality.

At stoneware temperatures the processes of oxidation and reduction during a firing can make a marked difference in colour and surface quality. Reduction requires a flame-burning kiln (gas, wood or oil) and the facility to reduce the amount of air in the kiln at temperatures above about 900°C (1652°F). In that kind of atmosphere the flames take oxygen from oxides in the clay and glaze, principally from red iron oxide (Fe_2O_3), which turns from red to black, and this can have a marked and very beautiful effect on the colour of the clay body and the glaze. The same glaze in oxidation is usually less shiny and fluid.

The main ingredient of most stoneware glazes is feldspar or a similar material. Feldspar can be thought of as a naturally-occurring frit which contains alumina, silica, and a flux – commonly potassium oxide or sodium oxide. Though there is a theoretical formula (potash feldspar $K_2O.Al_2O_3.6SiO_2$, soda feldspar $Na_2O.Al_2O_3.6SiO_2$) in practice none conforms exactly to this ideal. Other similar materials are nepheline syenite ($K_2O.3Na_2O.4Al_2O_3.8SiO_2$), which has a lower melting point, and Cornish stone ($K_2O.Al_2O_3.8SiO_2$), which is harder and more refractory. None of these materials is normally used on its own as a glaze since they have too high a melting point, so fluxes are added.

Fluxes at stoneware temperatures are calcium, barium, magnesium, sodium and potassium, and zinc. Each of these also imparts its own characteristics to the glaze and it is quite usual to include two or more in a glaze.

CALCIUM

Calcium is the commonest flux in stoneware glazes and is often present in combination with other fluxes as the principal or secondary flux. Whiting (calcium carbonate, $CaCO_3$) is the usual material for introducing calcium into a glaze. Although by itself it has a high melting point, in combination with feldspar it can produce a glaze that is very workable at stoneware temperatures. A high lime glaze is likely to contain at least 20 per cent whiting. An overload of lime will create a matt opaque glaze, but at slightly lower concentrations it is possible to get an attractive glaze that is semi-matt yet transparent enough to reveal a slip decoration underneath. The beautiful jade-green celadon glazes of the Chinese are lime glazes, which contain a small amount of iron oxide (1–3 per cent), and fired in reduction. Higher concentrations of iron can give rather dull browns. A small amount of copper (less than 1 per cent) can give a strong blood red in reduction if borax is also present.

BARIUM

Barium in the form of barium carbonate ($BaCO_3$) is known principally for matt glazes with an amazing colour response to certain metallic oxides. In small quantities (up to about 5 per cent) it heightens the brilliance of a clear glaze and the brightness of colours. Larger amounts will make an opaque glaze with a satiny surface, and concentrations of over about 20 per cent give a dry rough surface. Copper gives vivid blues rather than green, sometimes also with red when in reduction; cobalt gives greenish blues; in reduction iron tends to give yellows.

MAGNESIUM

The chief characteristic of these glazes is their smooth satin surface that is so pleasant to feel. According to how much is included in the glaze it can be semi-opaque to opaque (small amounts do not add much interest to a shiny glaze). The usual materials used are talc ($3MgO.4SiO_2.H_2O$) and dolomite ($CaCO_3.MgCO_3$). Even a tiny amount of iron in the glaze will give it a creamy colour rather than white, and greater concentrations of iron give dull muddy browns. Chrome does not work well with magnesium glazes but with cobalt it is possible to get pinks and violets. Nickel gives green.

POTASSIUM AND SODIUM

As with earthenware glazes, the alkalis at stoneware temperatures produce glazes which almost invariably craze, and so it is best to include this crazing in the overall visual effect of the glaze. The common feldspars contain potassium and/or sodium, so it is necessary to add only sufficient other flux (whiting, calcium borate frit, wood ash, for example) to produce a melt. With copper, alkaline glazes give a vivid turquoise colour, and they give good bright colours with other metal oxides.

ZINC

Zinc can be useful in a glaze in small quantities. It acts as a flux and can reduce crazing and strengthen the glaze surface. In larger amounts (5–10 per cent) it is refractory and will make a glaze opaque and slow to melt, sometimes making the glaze crawl. In greater amounts still it creates a dry rough surface. Bristol glazes devised in the nineteenth century as an alternative to lead

Bowl by Susan Nemeth, *Handbuilt porcelain fired to 1300°C (2372°F). The technique begins with a slab of clay which is decorated with several layers of coloured slips and inlays, then rolled and formed by press-moulding. Sponging off layers of slip reveals other colours underneath, adding to the richness of texture and detail. The surface is sanded down after a low biscuit firing to give a silky smooth, matt surface.*

glazes contain zinc as a flux. Cobalt blues and copper greens are intensified by zinc, but it has a bad effect on the colour of chromium and iron. Interesting blues and purple are possible with nickel, pinks with manganese.

GLAZE RECIPES

EARTHENWARE GLAZES

Clear lead glaze fired to 1060°C (1940°F):

	%
Lead bisilicate	72.8
China clay	12.1
Cornish stone	13.5
Flint	1.6

Clear lead glaze fired to 1040–1050°C (1904–1922°F):

	%
Lead bisilicate	72.1
Whiting	4.8
Potash feldspar	16.3
China clay	4.8
Bentonite	2.0

Light yellow lead glaze fired to 1060°C (1940°F):

	%
Lead sesquilate	65
Potash feldspar	5
Red clay	12.5
SMD ball clay (or Hyplas 71)	12.5
Whiting	5

Clear, shiny borax glaze fired to 1105°C (2021°F):

	%
Borax frit (Potterycrafts P2953 or similar)	60
China clay	20
Nepheline syenite	10
Flint	10

Lead/borax glaze fired to 1080–1120°C (1976–2048°F):

	%
Lead bisilicate	57
Borax frit (as above)	17
China clay	15
Whiting	9
Potash feldspar	24
Bentonite	2

Matt lead/borax glaze fired to 1160–1190°C (2120–2174°F):

	%
Lead bisilicate	36
Borax frit (as above)	17
China clay	15
Whiting	9
Potash feldspar	24
Bentonite	2

Clear and shiny lead/borax glaze fired to 1160–1190°C (2120–2174°F):

	%
Lead bisilicate	22.4
Borax frit (as above)	39.5
Potash feldspar	33.3
Talc	4.8

Slip-decorated tyg (drinking cup with two or more handles), *Staffordshire, England, early eighteenth century.*
This intricately slip-trailed cup, which is about ten inches high, was made in the local red earthenware clay, covered in black slip and then decorated with white slip. A clear lead glaze imparts a slight yellow tinge to the white. (Fitzwilliam Museum, Cambridge).

Lead zinc matt glaze fired to 1060°C (1940°F):

	%
Lead bisilicate	67
Potash feldspar	9.3
Zinc oxide	19
Quartz	4
Bentonite	0.7

ALKALINE GLAZES

Clear shiny glaze (usually crazes) fired to 1060°C (1940°F):

	%
Alkaline frit (Potterycrafts P2962)	80
Whiting	5
China clay	15

Clear glaze fired to 960–980°C (1760–1796°F):

	%
High alkaline frit	83
Ball clay	14
Bentonite	3

White alkaline glaze fired to 980–1000°C (1796–1832°F):

	%
High alkaline frit	78
China clay	15
Tin	5
Bentonite	2

STONEWARE GLAZES

Clear, shiny reduction glaze fired to 1280°C (2336°F):

	%
Potash feldspar	35
Flint	21.25
Whiting	61.25
Ball clay (SMD or Hyplas 71)	27.5

Stoneware reduction glaze fired to 1280°C (2336°F):

(Bright pale green, clear and shiny)

	%
Potash feldspar	26.6
Whiting	25.6
Ball clay (as above)	10.8
China clay	18
Flint	19
Chromium oxide	.25

Barium matt glaze fired to 1280°C (2336°F) reduction:

(A white glaze with an eggshell finish)

	%
Nepheline syenite	49
Barium carbonate	18
Dolomite	4
China clay	9
Flint	18
Bone ash	2

White magnesia glaze fired to 1280°C (2336°F) reduction:

(Semi-matt finish)

	%
Potash feldspar	43
Calcium borate frit	12
Dolomite	7
Talc	14
China clay	5
Flint	19

11 KILNS AND FIRING

Firing is the stage where all the potter's work of making and decorating is put to the test. No matter how careful and meticulous the preparation, no studio potter can be completely certain what the pots will be like when the kiln is eventually opened. The anticipation is exciting and a little scary, and for good or bad the first sight is always tempered by the expectation of how it should look. With experience the potter learns how to control all the many variables in the materials and the kiln so that each firing is less of a trauma and more like an adventure.

REDUCTION

Clays can be fired to any temperature from 700–1300°C (1292–2372°F) and in a variety of conditions. Being mostly clay, slips tend to behave in a similar way, though the presence of oxides may well alter the result.

The presence or absence of oxygen in the kiln can have a marked effect on the colours in clay, glaze, and slip. Reduction is the name given to the process whereby the amount of oxygen in a kiln is restricted so that the gases in the kiln, desperate to find oxygen, attack the clay and glazes of the pots and take oxygen from them. In fact, the action is limited to a few metal oxides – principally iron, copper, and lead – and of these it is generally the reduction of iron that is made use of to achieve the characteristic look of a reduced pot. Iron is present in all clays and glaze materials, so even when none has been added there is bound to be a difference between an oxidized and a reduced pot.

In reduction, iron in the form of red iron oxide, Fe_2O_3, is converted to black iron oxide, FeO. The resultant change in clay and glazes is usually very attractive, giving a more subtle, greyer range of colours. Black iron oxide is a strong flux, so large particles in the clay will melt into the glaze, creating iron spots – another common feature of reduced stoneware. Clay that is creamy or buff-coloured in oxidation will be greyish in reduction. Oxidized porcelain is a creamy white, but in reduction it is a beautiful bluish white.

The reduction of iron is reversible at high temperatures unless protected by a glaze, so the unglazed parts of a pot are likely to re-oxidize to an extent, with some areas going on orangey-red. The same will happen to unglazed slips unless they have begun to vitrify. Slip colours will generally be darker and greyer than when oxidized. Reduction has traditionally been done in stoneware firing, although iron oxide can be reduced from about 900°C (1625°F) upwards.

Lead is badly affected by heavy reduction – going black and blistering – but can be used in light reduction in earthenware glazes where it enhances the effect of iron reduction giving darker, subtler colours.

Flame-burning kilns using gas, oil, or wood are ideally suited to reduction firing because they need oxygen to burn, and so it is easy to starve the kiln of air, thus creating a reducing atmosphere. A wood-burning kiln offers more. The wood ash contains fluxes which can cause 'flashing' – unglazed areas that become slightly glazed as a result of the flames licking round the pots. The wood ash also acts on the glazes to make them melt more.

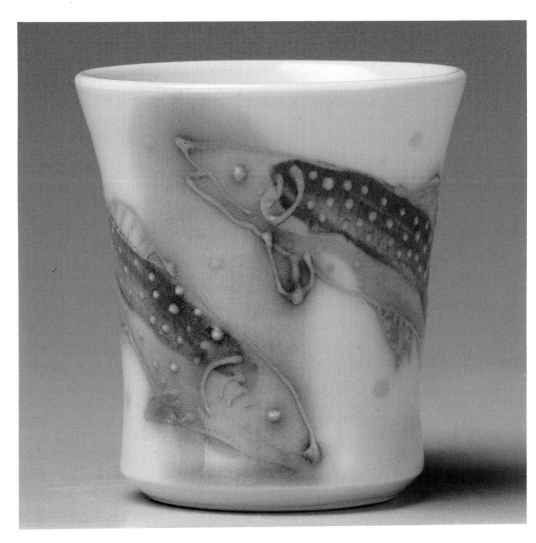

OXIDATION

An oxidized firing is one in which there is plenty of oxygen in the kiln at all times so that there is no possibility of the metal oxides in the clay and glazes being deprived of oxygen and so altering their state. It is most conveniently done in an electric kiln because there is no burning and so no danger of accidental reduction, but it can also be achieved in a fuel-burning kiln with a little care.

It is often said that oxidized stoneware glazes are not as attractive as reduced glazes. The interaction between body and glaze that exists in reduction is not present to nearly the same extent, and colours tend to be harsher, so more is left to the potter to devise interesting effects by imaginative use of materials. Perhaps the judicious combination of slips and glazes could be one way of providing that interest.

At earthenware temperatures oxidized firing is usual, particularly if lead glazes are used, but there are always exceptions – wood-fired earthenware is especially vibrant and rich in tone and the slightly-reduced lead glazes seem to capture for ever the action of the flames.

Mug by Kochevet Ben-David, *Thrown in white stoneware clay and decorated by trailing and brushwork with coloured slips. Fired to 1260°C (2300°F) in an electric kiln.*

SAWDUST FIRING

In a sawdust firing the pottery is not glazed. It is embedded in sawdust in a dustbin-like container and the sawdust is then set alight from the top to smoulder very gently, without a flame, for several days until completely burnt out. The pots are fired to a low temperature (800–900°C (1472–1652°F)) and so are quite fragile, but the surface patterns created by the burning sawdust are stunning with smokey-black, red, brown, yellows, and greys possible, depending on what clay has been used, the composition of the sawdust, and the presence of air pockets in the kiln pack. The low-firing temperature means that the pots retain the shine of burnishing very well. To overcome the fragility problem it is possible to biscuit-fire beforehand to a higher temperature to make the clay stronger. Sawdust firing is excellent for any slip decoration technique. Body stains are not very effective at such low temperatures, however, and oxides will need to be used in greater quantities to get sufficient colour.

SALT-GLAZE

Salt-glaze is another method ideally suited to the use of slip decoration. During firing salt is thrown into the kiln, where it vaporizes and reacts with the alumina and silica in the clay of the pots to form a hard glaze with a very characteristic 'orange peel' surface. It is most effective on stoneware fired to 1220–1280°C (2228–2336°F), but can be used on earthenware from 1100°C (2012°F) upwards. Firing is normally by gas or oil. The salt attacks not only the pots but also the kiln and kiln furniture, glazing those surfaces too, so salt firings must be done in a kiln specially designed for the purpose.

Salt-glazing can be done in oxidizing or reducing conditions. The colours in reduction will be darker and less bright. Oxides need to be used very sparingly since the process is very sensitive to small variations. Different ball clays used as a slip will give shades of brown depending on the amount of iron oxide contained, and yellows and oranges are also possible. A $\frac{1}{2}$–1 per cent cobalt carbonate in a slip will give strong blues, whilst grey-blues can be obtained with the inclusion of an equal proportion of nickel oxide. Ten per cent rutile in a slip gives a lovely lustrous yellow/tan colour, and with cobalt gives a pale pearly green (10 per cent rutile + $\frac{1}{2}$ per cent cobalt oxide).

RAKU

The drama of taking a red-hot pot out of a kiln and plunging it into sawdust, wet leaves, or straw makes raku an exciting and involving activity. The process comes from Japan but is becoming increasingly popular in this country. Raku is normally fired at 750–1000°C (1382–1832°F). Sawdust, leaves, or any other combustible material act like a combination of a reduction firing and a sawdust firing, reducing the clay and glazes, blackening unglazed areas and showing up the crazing in the glazes. Slips can be used freely to go underneath glazes or can be left unglazed. Glazes are normally low-temperature alkaline, lead, or borax glazes.

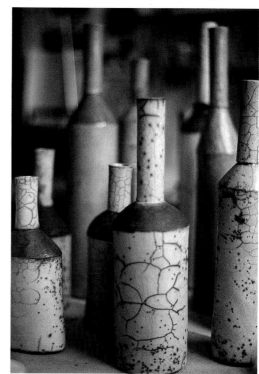

Raku bottles by Eva Baratta, *Hand-built and dipped in coloured slips. Raku fired.*

12 A SHOWCASE OF POTTERS

CLIVE BOWEN

Traditional shapes and simple, bold slip decoration are the hallmarks of Clive Bowen's work. His pottery comes from the Devon tradition where he learnt his skills and the influence of Michael Cardew, with whom he worked, is strong. He works on a large scale, firing in a huge wood-burning kiln which he built himself. The colours of the pottery are mainly black and honey yellow – a classic combination. The quality of the throwing, the clay, and the glaze create the awareness that the pots really are from the earth.

All the pottery, from teapots to huge garden pots, is thrown. Clive uses Fremington clay (red earthenware), washed for slipware, and 'as dug' for the garden pottery. Slip is applied when the pots are leather-hard. Pots are dipped in black slip, but larger ones have the slip brushed on.

Three methods of decoration are used – trailing, sgraffito, and combing, in which fingers or a comb are run through the wet slip. The slip colours range from yellow to

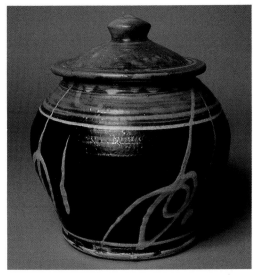

Lidded jar by Clive Bowen, *Thrown with slip-trailed decoration. Honey glaze fired in a wood-burning kiln to 1040–1060°C (1904–1940°F).*

black depending on how much iron or manganese is added. There is no biscuit firing. Once decorated the pots are dipped in a honey-coloured glaze and are then fired in the wood-burning kiln to 1040–1060°C (1904–1940°F) The firing takes 24 hours.

CLAY
Fremington – washed for slipware
 unwashed for garden pots

SLIPS
White – Peters Marland stoneware clay
 sieved through 120 mesh
Red – Own clay from field
Black – Fremington clay
 Red iron oxide

GLAZES
Clear fired to 1040–1060°C (1904–1940°F):
(for outsides only)

	%
Galena	60
Clay	30
Flint	10

Yellow fired to 1040–1060°C (1904–1940°F):

	%
Lead bisilicate	69
Clay	27
Flint	3
Bentonite	1
Red iron oxide	1

SIDDIG EL'NIGOUMI

Siddig El'Nigoumi brings the African and Arab tradition of his homeland, Sudan, to his pottery. He works on red earthenware with sgraffito designs and burnishes the surface to a satin sheen without using any glazes. Though trained in Britain his designs are strongly influenced by his background. Many have intriguing geometrical designs, beautifully drawn but deliberately never quite perfect. Ideas for motifs come from African and contemporary British sources – African rock paintings, or the CND symbol, for example. North African tooled brasswork is another strong influence.

For plates and dishes Siddig uses concave plaster moulds which he makes himself. Other shapes are coiled, thrown, or slab-built. For burnished ware he uses Fremington red earthenware clay because it is light in colour, smooth, and fires to a fairly low temperature. Pots are made as thin as the size will allow. Slips are made from the same clay, if possible, to avoid any problems with fit between slip and body. Three colours are used – red, black and white – and the slip is used quite thickly and applied with soft brushes at the leather-hard stage.

The sgraffito design is made when the pot is completely dry, so the next stage after the slip is to burnish. This is done at quite a late leather-hard stage to minimize the amount of water evaporating through the burnished surface because it kills the shine. Burnishing

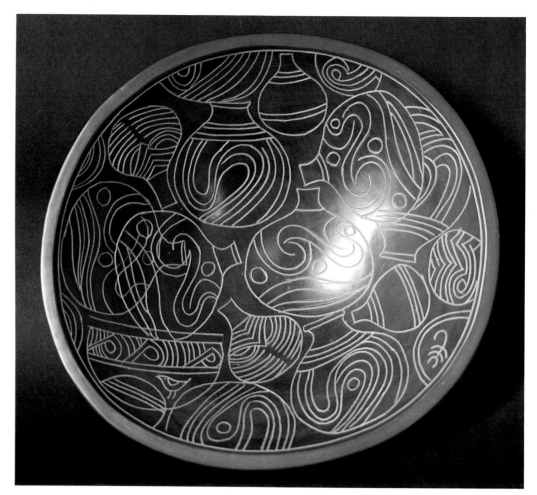

Dish by Siddig El'Nigoumi, *Moulded in red earthenware clay, slipped and burnished. Sgraffito decoration. Fired to 800°C (1472°F) in an electric kiln and then smoked.*

tools are the back of a teaspoon, polished pebbles, chrome-plated rod, or anything else that comes to hand. Siddig's method to test when to stop burnishing is to rub the surface with one finger (making sure the skin of the finger is smooth). If it makes a squeaky sound then more burnishing is needed. Burnishing should stop when no squeaking can be heard. When finished, the pot is left to dry completely before being decorated. A steel knitting needle is the main sgraffito tool used to scratch through the slip layer.

Pots are fired to 800°C (1472°F) in an electric kiln. Sometimes he enhances the colours of a pot by smoking it after firing. A torch of rolled newspaper (the tabloids are best because they contain more resin) is held under the pot. When cool, the loose soft soot is brushed off leaving a warm smokey stain that gives an effect like that from an open fire kiln.

SLIPS
White slip

	%
Ball clay	97
Talc	3

Red slip
Fremington clay (or whatever the pot is made of)	90
Red iron oxide	10

Black slip
Fremington clay (or whatever the pot is made of)	95
Cobalt oxide	1.5
Manganese dioxide	3.5

PETER DICK

At Coxwold Pottery in Yorkshire Peter Dick makes use of coloured slips to decorate his earthenware and wood-fired low stoneware. The shapes are generally traditional – of the English country pottery style – and the colours are rich and strong. Decorative designs are based on plant, animal, and fish forms as well as textile patterns.

Most of his pottery is thrown, and larger pots are constructed out of two or more thrown pieces joined together at the leather-hard stage. The clay is Staffordshire red with additions of ball clay, fire clay, and sand to suit particular wares. Handles and lugs sometimes take the shape of human or animal forms, giving pots a spark of life that can be amusing and also unsettling.

Slip is used in various ways for decoration. To begin with a single white or black slip is poured or brushed onto the pot in a deliberately uneven way. Sometimes on flat plates the decoration is put on whilst the background slip is still wet. When the plate is banged firmly down the pattern moves and melts giving a delightfully fluid feel. On curved or vertical surfaces the background slip is left until dry to the touch before patterns are applied with slip trailer and brush. Oriental brushes allow variation of colour, line, and texture which work well with slip-trailing. Paper resist and sgraffito are also used occasionally.

About half the pottery's production is fired in an electric kiln to Orton cone 04–02 (between 1060 and 1120°C [1940–2048°F]). The pots are clean and bright with blue and green slips predominating. The rest of the pots are fired in a large (100 cubic feet) wood-fired kiln to a temperature around Orton cone 6 (1210°C [2210°F]). Wood-firing is much more unpredictable, and fluctuations in kiln atmosphere and the presence of fly ash give a wide variation in colour and texture. There is a wonderful sparkle where iron and manganese have fused into the glaze, giving a very rich quality to the colours.

GLAZES
Suzi's earthenware glaze Orton cone 04–02 (1060–1120°C [1940–2048°F])

	%
Lead bisilicate	72
Cornish stone	4
Whiting	2
HVAR ball clay	5
Red clay	16
Bentonite	1

Low stoneware Orton cone 5–6 (1190–1210°C [2174–2210°F])
Potterycraft P2019

Low-solubility glaze	88
Cornish stone	6
Bentonite	6
Red iron oxide	2.5
Purple iron oxide	1
Manganese dioxide	0.5

SLIPS

Black slip

Red clay slip	100
Manganese dioxide	4
Red iron oxide	2
Purple iron oxide	2

White slip

| HVAR ball clay | 100 |

Buff/gold slip

| Potclays buff clay 1120 | 100 |

Green slip

| HVAR ball clay | 100 |
| Red copper oxide | 5 (light) |

For a darker green, add 7.5% red copper oxide

Blue slip

| HVAR ball clay | 100 |
| Cobalt oxide | 0.5 (light) |

For a darker blue, add 1.5% cobalt oxide

CLAY BODY

Potclays red earthenware 1137 with additions

For teapots	5% fine silica sand
For cookpots	10% coarse silica sand + ball clay
For big plates	fireclay

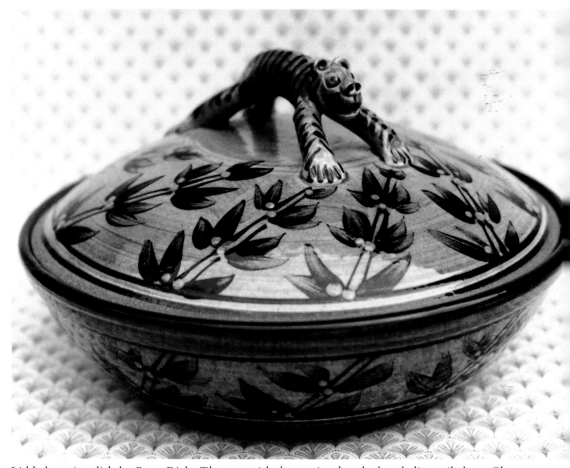

Lidded serving dish by Peter Dick, *Thrown with decoration brushed and slip trailed on. Clear glaze fired in a wood kiln to 1210°C (2210°F).*

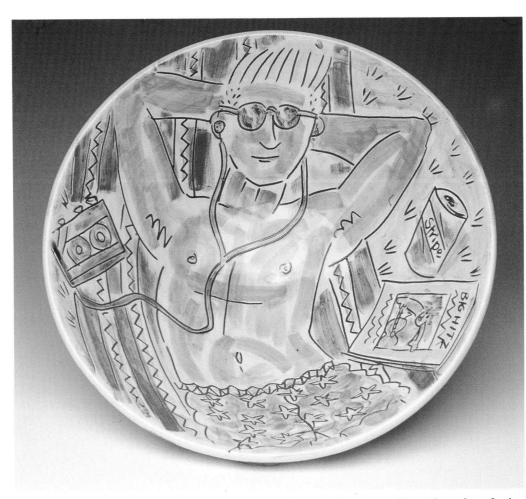

Bowl by Mike Levy, *Thrown and decorated with brushwork and sgraffito. Clear glaze fired to 1120° (2048°F) in an electric kiln.*

MIKE LEVY

Mike Levy makes colourful and lively earthenware pottery. He uses sgraffito and painted slips to decorate and his designs range from a fairly standard floral motif to one-off pieces with figurative decoration based on contemporary themes – incisive witty comments on people and situations.

Most of the pots are thrown with a mixture of red and white earthenware clays. Most shapes are turned before slipping, though large vases are half-turned, slipped inside, left to dry to leather-hard, turned again, and slipped outside. Mike likes to cover the whole pot including the base in a white slip before decorating.

Many of his pots have a turned hollow foot, and his routine for slipping is quite complex. Here is his description of how to slip a bowl.

First slip the inside and pour out, holding the bowl by the foot and shaking with a twisting motion to remove surplus slip. Wipe slip from the rim with a natural sponge and leave to dry on a piece of bubble wrap to support the middle. Next dip the top half of the outside by holding the bowl by the foot and pushing the bowl down into slip half way. Shake off excess slip and leave to firm up again. Finally, hold the bowl by the rim and dip the bowl into slip base first to overlap with the top half. Dip at an angle so that air can escape from under the foot. The slip should have the consistency of single

cream.

Some pots are sprayed with slip, though it does not give such a good surface on which to decorate. Teapots are slipped inside before being turned and sprayed on the outside.

Designs are sketched onto the background slip with a Faber-Castell 2900 6B pure graphite pencil, which is soft enough not to scratch the surface, before the pots are painted; sgraffito is done last. Underglaze colours are mixed with equal amounts of glycerine and slip to give a thick oil paint consistency which can be thinned with water during use. The decoration is simple and bold so confident strokes with a broad watercolour brush give the best results. Colours are applied in layers rather than mixed to give a richer result.

Sgraffito is done with a painted tool when the pots are at the firm leather-hard stage. The process creates toxic clay and underglaze colour dust so a dust mask should be worn. Excess clay is brushed off with a broad flat brush.

The pots are biscuit-fired to 1120°C (2048°F), higher than the glaze firing. Mike finds that this helps to prevent the slip shelling off after glazing and less of the slip dissolves into the glaze. He adds a tiny amount of magnesium sulphate (Epsom salts) dissolved in hot water to thicken the glaze if there are problems with the glaze sticking to the pot due to lack of porosity. Some pots, including large bowls, are fired on stilts, which ensure the glaze matures in the cold spot underneath and reduce the risk of cracking. They are glaze-fired to 1050°C (1922°F) and soaked for 45 minutes.

CLAY

2 parts white earthenware (Potclays 1141)
1 part red earthenware (Potclays 1135)

SLIP

3 parts SMD ball clay
2 parts china clay

GLAZE

Transparent low-solubility glaze (Potterycrafts P2038)

PRUE VENABLES

A whole range of slip-decorating techniques go into producing the intricate designs of Prue Venables' tableware. Built up layer by layer they have a depth that gives them much more interest than would be expected from each technique alone.

The pots are delicate-looking and carefully made. For Prue it is important that they work well and are enjoyable to use. Everything is thrown and turned two or even three times to make sure they are the right thickness and weight. The clay is a white earthenware which is difficult to throw and prone to distortion, so everything is made on individual bats. The pots are decorated when they are leather-hard or slightly drier. Prue uses slips, underglaze colours mixed with a glaze binder, and ready-mixed Duncan colours.

The first layer of decoration is a base colour which is sponged on. The design is then built up first with brush strokes; these form the basis of the design and the choice of brushes is important. Prue uses a whole variety of shapes and sizes, especially long-hair brushes and cut liners which she buys from Stoke-on-Trent. Over the brushwork comes slip-trailing and then sgraffito.

Prue solves the problem of slip on handles (wet slip can make them collapse) by leaving them unslipped and attaching them half-way through the decorating process. This also allows any blemishes to be touched up easily.

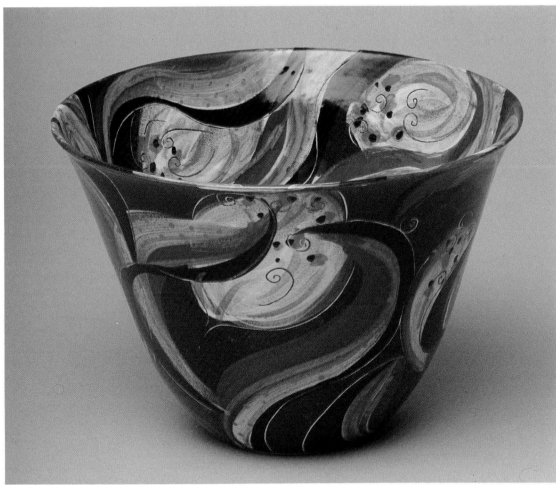

Bowl by Prue Venables, *Thrown with decoration using brush, sgraffito and sponging. Clear glaze, white earthenware clay fired to 1200°C (2210°F.).*

The pots are biscuit-fired to 1200°C (2192°F) to mature the clay. This also makes them almost non-porous and reduces the dangers of the glaze crazing, but it also makes it harder to put on the glaze. To overcome this Prue sprays on the glaze after first heating up the pots. The glaze firing is in an electric kiln to 1060°C (1940°F) followed by a soak.

WHITE SLIP

	%
Ball clay	60
China clay	40

Coloured slips made by adding oxides and body stains sometimes sieved and sometimes left coarse.

GLAZE

Potterycrafts P2018 low-solubility glaze.

GABRIELLE KOCH

The subtle colouring of the large almost spherical forms comes directly from the marks of the fire. All Gabi Koch's pots are fired in a sawdust kiln, a long and smokey process that does not endear her to her neighbours. The results are reminiscent of African pit-fired pottery with an added refinement that is not at all out of place.

The making process and the size of the forms put a lot of stress on the pots, so they have to be built very carefully. A 50/50 mixture of T-material and porcelain is used. T-material is a proprietary clay that is excellent for withstanding the stresses in making and firing; porcelain is included to improve the finished colour. The bases are rounded, so they are started off from a slab formed over a hump mould, then transferred to a dish mould to support the shape as the sides are built up with flattened coils. To adjust the shape as it grows the outside is beaten with a wooden slab, with a hand kept inside to support it. Great care is taken that the walls are of even thickness and that no cracks appear.

When the building is complete, the pot is scraped down with a metal kidney to roughen the surface and painted with a slip made of the same clay sieved through an 80 mesh to remove grog. The pots are usually burnished three times. The first burnish obliterates the brush strokes and lays the foundation; the second gives a good shine, and the third gives a luxury finish. The drier the pot the greater the shine, though if it is too dry it scratches. Household spoons make the best burnishing tools.

The pots are biscuit-fired to 1000°C (1832°F) in an electric kiln to give them the strength to survive the sawdust firing. An old oil drum or dustbin, or a brick enclosure with no air holes in the side, can be used for sawdust firing. The pot is packed with sawdust inside and all around. Soft wood sawdust is the best. Coarse sawdust makes livelier patterns on the pot; finer sawdust gives more even colour; so by careful packing it is possible to have some control over the finished result. The kiln is set alight from the top and it burns for four to five days, gently smouldering.

After firing the pot is polished with beeswax. Gabi varies the colour of the clay body by adding othe clays and body stains. Reds and pinks can be achieved by adding up to one-third red clay to the body and slip. Body stains can also be used, but at these low temperatures a large addition is needed to get a noticeable colour.

Large vessel by Gabrielle Koch, *Hand-built in porcelain and T-material clays. Slip brushed on and then burnished. Sawdust-fired.*

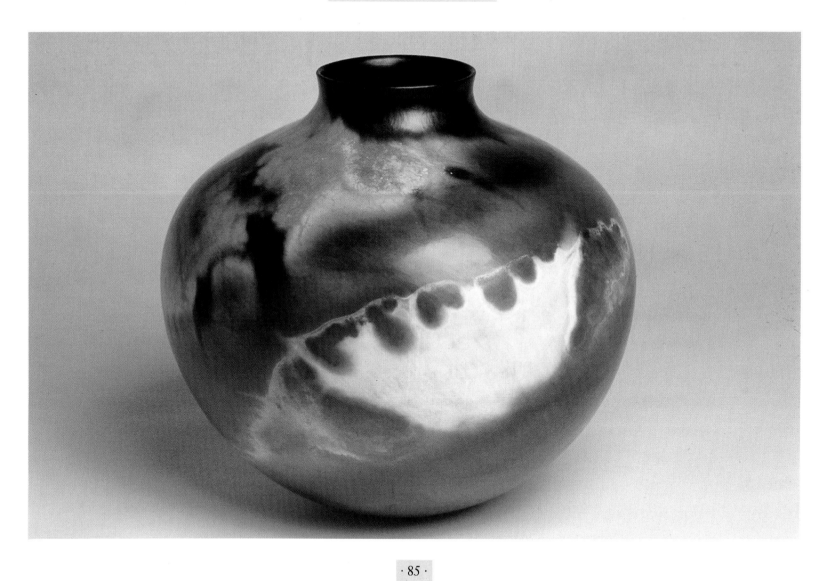

FIONA SALAZAR

Fiona Salazar displays a skill that is quite breathtaking. Her pots are hand-built and hand-decorated, yet every form seems perfect in shape and construction, every line exactly right. Her vases and lidded pots are individually designed with the decoration carefully matching the form. They are low-fired and burnished on the outside, and are usually 30–50 cm (12–20 in) high.

She starts building the form by throwing the lower part, and the initial shape dictates how the rest of the pot will develop. On top of the thown base coils are used to build up the pot. Five or six pots are made in a batch so that Fiona always has a pot to work on whilst others are stiffening. The sides are smoothed with metal scrapers and pressed into shape with wooden beaters.

Fiona uses a terra sigillata slip to coat the pot and it is sprayed on when the pot is leather-hard. When the slip has dried back to leather-hard it is burnished once or twice with a variety of tools. The back of a metal spoon is a favourite, but other tools are used to get into the sharp angles and awkward corners. The decoration is painted on after the whole pot has been burnished. Body stains, oxides, and glaze stains are used in a white slip; they are added by eye rather than by measurement. The painting requires confidence and assuredness for mistakes cannot be rectified. The outlines are painted first and then the inside filled in. More than one coat may be necessary. Each colour is applied and burnished before the next is added.

The pots are fired to Orton cone 09 (about 925°C [1697°F]) very slowly to avoid cracking, taking 18 to 20 hours. They are glazed on the inside with a low-expansion frit glaze coloured with glaze stain and refired to cone 09. Finally the pot is warmed and polish applied to recapture the quality of the original burnishing.

TERRA SIGILLATA SLIP
3500 ml (123 fl. oz) water
1500 gm (53 oz) white ball clay
7.5 gm ($\frac{1}{4}$ oz) sodium hexameta phosphate (SHP)

Add clay and water and allow to mix. Grind the SHP and add it to the slip. Shake and then leave to stand for about 48 hours. Syphon off the top layer of water, then syphon off and use the next layer of fine clay particles in suspension. It can be thickened by the addition of a small amount of calcium chloride.

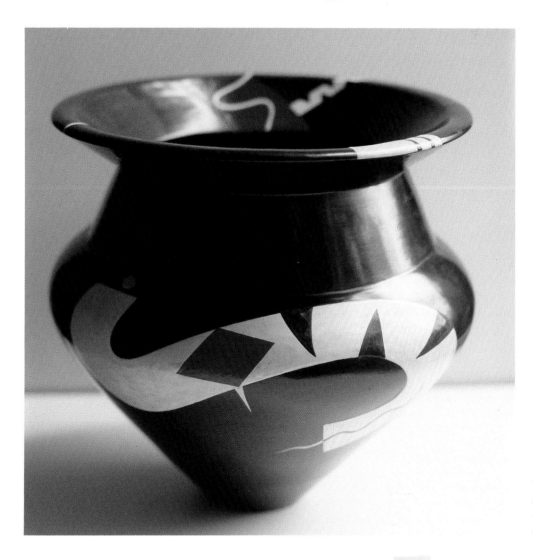

Vase by Fiona Salazar, *Thrown and hand-built. Slip sprayed and brushed on and then burnished. Fired to 925°C (1697°F) in an electric kiln.*

SANDY BROWN

This is pottery that exudes life. Sandy Brown has tremendous energy and this becomes immediately obvious in her pottery. She uses bright colours – red, blue, green, black, and yellow – and brushes and trails them on with exuberance. Tableware, individual pieces, and sculpture are all in her repertoire.

Sandy started working in earthenware before moving over to stoneware but her techniques are still similar. She now decorates with glazes but they have the feel of slips and she still puts a white slip over the clay body to give it whiteness and softness. The tableware is thrown or slab-built – lumpy teapots and luscious lasagne dishes. Other work is coiled, moulded, slab-built, and sculpted.

The white slip is put on at the leather-hard stage and the pots are then dried and biscuit-fired. The decoration is put on and a clear glaze goes over. The pots are fired to 1270°C (2318°F) in a gas kiln in a neutral atmosphere.

CLAY
Hyplas 71 plus 10% grog

WHITE SLIP

	%
Powdered Hyplas 71	60
China clay	40
Zircon silicate	1.5

Platter by Sandy Brown, *Hand-built and decorated with coloured glazes. Fired in a gas kiln to 1270°C (2318°F).*

Bowl by Sheila Casson, *Inlay, paper resist and sgraffito, reduced stoneware.*

SHEILA CASSON

There is a gentleness to Sheila Casson's pottery that softens the geometric patterns and gives them an extra dimension. It is the effect of stoneware glaze over slip and the reaction between them that is so much harder to get at earthenware temperatures. Her patterns seem abstract but the ideas come from the landscape where she lives, with the influence of the Mimbres pottery of the early American Indians, and oriental carpets.

All the forms are thrown except for a few large dishes which are press-moulded. Sheila works in both porcelain and white stoneware. Sheila uses inlay, paper resist, and sgraffito techniques and the decoration needs to be done on a smooth surface at the leather-hard stage. The designs are neat and precise and need to be worked out in advance. Inlay, if used, is done first, then paper resist with an iron slip is lightly sprayed over. To keep the iron colour paper resist is used again over the iron slip and a blue slip sprayed over. Finally sgraffito is used through to the body which gives white lines and areas.

The pots are biscuit-fired and then glazed with a 50/50 mixture of a dolomite and tin glaze and a magnesium glaze sprayed on. They are fired to 1280°C (2336°F) in a gas-reduction kiln.

Three colours result from the two slips – an iron-black, blue, and a grey to greenish-blue where they overlap. The thickness of the slips is critical to the colours.

CLAY BODY

	%
ECC Hyplas 71	75
ECC Porcelain powder	24
Cornish stone	1

VITREOUS IRON SLIP

	%
Cornish stone	60
Ball clay	35
China clay	5
Red iron oxide	100

This slip is mixed 50/50 with a red clay slip and a little gum arabic is added.

BLUE SLIP

	%
Ball clay	100
Red iron oxide	6
Manganese dioxide	3
Cobalt oxide	1

DOLOMITE AND TIN GLAZE

	%
Potash feldspar	24
Soda feldspar	24
China clay	24
Dolomite	21
Whiting	3
Tin oxide	4

JOSIE WALTER

Josie Walter makes good use of the qualities of slip. Her decoration is applied in layers and the opaqueness of slip makes that easy to do. The slip drapes itself over every edge and gives her work a softness that is very appealing. The pots are colourful, dramatic, and friendly. Her decorative ideas come from what she sees around her, though fish are a recurrent theme and paintings are a strong influence.

Many pots are thrown with the minimum of turning, but Josie makes a range of open dishes which are not round – oval or heart-shaped, for example. These are made by throwing the sides separately from the base and joining the two in the desired shape. Other pots are hand-built from a rolled slab. The shape of the pot is marked out on the slab with an additional 2.5 cm (1 in) allowed for the sides. The sides are then turned up, and at corners and bends where the clay overlaps small wedges are cut out and later pressed back on to reinforce the join. A rim is added to soften the cut edge. Josie waxes the bottom of all her pots with a wax emulsion resist as soon as they are dry enough to handle. This helps to keep the bottom clean and slips and glaze fall off easily.

A variety of coloured slips are used to decorate. Sometimes several layers of paper resist are used with slip-trailing and brush work applied before, between layers, and

Lobster dish by Josie Walter, *Handbuilt in red earthenware clay. Decorated by paper resist and slip-trailing. Raw glazed and fired in an electric kiln to 1100°C (2012°F).*

afterwards, creating an effect which makes it look more three-dimensional. Josie finds the best paper for resist work is florists' wrapping paper because it adheres well to the clay, does not let slip creep under the edges, and gives a nice clean edge when removed.

The pots are all raw glazed so as soon as decorating is finished and the pots are dry enough to handle they are dipped in glaze just as if it were another layer of slip. They are fired to cone 03 (about 1100°C [2012°F]) in an electric kiln.

CLAY
Red earthenware from a variety of sources

SLIPS
White — TWVD ball clay
Coloured slips are made with oxides and stains added to TWVD ball clay.

Green — 3% copper oxide
Pale blue — 5% blue underglaze
Dark blue — 15%
Strong red — 15% red underglaze
Pink — 15% rose pink stain from Deancrafts

Black slip

Thick red clay slip	2.0 l	4 pt
Red iron oxide	40 gm	1½ oz
Black nickel oxide	25 gm	1 oz
Cobalt oxide	25 gm	1 oz
Manganese dioxide	25 gm	1 oz

Clear glaze cone 03 fired to 1100°C (2012°F)

	%
Lead bisilicate	80
Red clay	10
Potash feldspar	10
Bentonite	4

FELICITY AYLIEFF

Inlay and agate are the two principal techniques that Felicity Aylieff uses to make her remarkable pots. They are not glazed or burnished and this leaves the clay surface accentuating the design. Felicity uses strong colours often in very bold patterns that fill the whole surface of the pot.

The quality of the colours is important and this has led Felicity to use a white earthenware clay (Fulham FP2002) even though it is very difficult to build with. The advantages are that it vitrifies at 1220°C (2228°F) – a good temperature for stains. It is a warm white (other clays are too creamy which deadens colour additions), and is smooth in texture, allowing the surface to be rubbed down without scratching and so giving sharp definition to the inlay.

Much drawing preparation is done before starting work. Four or five pots are worked on at one time because the clay cannot take the addition of more than one or two coils at one go. The exact shape is formed as the sides are built – this clay cannot take much manipulation. Felicity uses agate (a rough mixture of two or more coloured clays) in the form of coils and slabs, twisting coils together or sandwiching slabs, always thinking about the interaction between the form and the decoration.

Inlay decoration is used because it gives very clear coloured areas and is integral with the surface of the pot. The pot is completely built and allowed to become leather-hard before the design is plotted on. The process is fairly quick: the outline is scored and then the area to be inlaid is cut out to a depth of about 3 mm (⅛ in). The surface is cross-hatched and dampened and then the coloured or agate clay is pressed in until flush with the surface. The pot is then wrapped in polythene and left to even up in consistency before the next bit of inlay is worked.

Drying is slow in order to avoid cracking and warping. When the pot is almost dry the inlay is scraped almost – but not completely – clear and the surface burnished to compact the inlay. Then the whole surface is rubbed lightly with the soft inside of a nylon pan scourer. Firing is to 1220°C (2228°F) in an electric kiln. Once fired, the pots are rubbed over with wet and dry paper and oiled lightly to make a smooth rich surface colour.

Felicity uses a variety of manufacturers' body stains and under-glaze stains. The powders are mixed to a paste and then wedged into plastic clay.

Vase by Felicity Aylieff, *Hand-built in white earthenware clay, inlaid with coloured clays. Fired to 1220°C (2228°F) unglazed.*

BIBLIOGRAPHY

Bankes, George *Moche Pottery from Peru*, British Museum Publications, London 1980

Barber EdwinAttlee *Tulip Ware of the Pennsylvania-German Potters*, Dover Publications, New York 1970

Brears Peter C.D. *The English Country Pottery, Its History and Techniques*, David and Charles, Devon, 1971

Brears Peter C.D. *The Collectors Book of English Country Pottery*, David and Charles, Devon, 1974

Brody J., Leblanc Steven A., Scott Catherine J. *Mimbres Pottery*, New York 1983

Chami E. *L'Art Ceramique du Beauvaisis au XVe et XVIe Siecle*, Cahier de la Ceramique No. 30

Charleston, Robert J. *Roman Pottery*, Faber and Faber, London 1955

Charleston Robert J., ed *World Ceramics*, Hamlyn, London 1968

Clark Kenneth *The Potter's Manual*, Macdonald, London

Cooper Emmanuel *Cooper's Book of Glaze Recipes*, Batsford, London, 1987

Cooper Emmanuel and Royle Derek *Glazes for the Studio Potter*, Batsford, London 1978

Fraser Harry *Glazes for the Craft Potter*, London 1973

Gibson John *Pottery Decoration, Contemporary Approaches*, A and C Black, London 1987

Green David *A Handbook of Pottery Glazes*, London 1978

Hamer Frank *The Potter's Dictionary of Materials and Techniques*, Pitman, London 1975

Honey, William B. *European Ceramic Art from the End of the Middle Ages to 1815*, London 1963

Jewitt Llewellyn *The Ceramic Art of Great Britain from Pre-Historic Times to the Present Day*, London 1878'

Leblanc Steven A. *The Mimbres People, Ancient Pueblo Painters of the American South West*, Thames & Hudson, London, 1983

Lehmann Henri *Pre-Columbian Ceramics*, 1962

Lothrop Samuel Kirkland *Pre-Columbian Designs from Panama*, 1976

Medley, Margaret *The Chinese Potter*, Oxford 1976

Noble, Joseph Veach *The Techniques of Painted Attic Pottery*, Watson Guptill, New York 1966

Rhodes Daniel *Stoneware and Porcelain*, London 1960

Rhodes Daniel *Clay and Glazes for the Potter*, London 1973

Wondrausch Mary *Slipware*, A and C Black, London 1986

INDEX